McCARTHY'S FIELD GUIDE TO GRAMMAR

SQLO CERT CHTTADAS

McCARTHY'S FIELD GUIDE TO GRAMMAR

NATURAL ENGLISH USAGE AND STYLE

PROFESSOR MICHAEL McCARTHY

Chambers

First published in Great Britain under the title Grammar and Usage: Your Questions Answered

First published in Great Britain by Chambers in 2021 An imprint of John Murray Press A division of Hodder & Stoughton Ltd, An Hachette UK company

2

Copyright © Michael McCarthy 2021

The right of Michael McCarthy to be identified as the Author of the Work has been asserted by him in accordance with the Copyright, Designs and Patents Act 1988.

All rights reserved. No part of this publication may be reproduced, stored in a retrieval system, or transmitted, in any form or by any means without the prior written permission of the publisher, nor be otherwise circulated in any form of binding or cover other than that in which it is published and without a similar condition being imposed on the subsequent purchaser.

A CIP catalogue record for this title is available from the British Library

Hardback ISBN 978 1 529 39351 4 eBook ISBN 978 1 529 39353 8

Typeset by KnowledgeWorks Global Ltd.

Illustrations © Jake Tebbit 2021

Printed and bound in Great Britain by Clays Ltd, Elcograf S.p.A.

John Murray Press policy is to use papers that are natural, renewable and recyclable products and made from wood grown in sustainable forests. The logging and manufacturing processes are expected to conform to the environmental regulations of the country of origin.

John Murray Press Carmelite House 50 Victoria Embankment London EC4Y 0DZ

www.chambers.co.uk

CONTENTS

Introduction	vi
What is a field guide to grammar?	vi
Why do we need a guide to grammar?	×
How to use this book	xi
Grammar and usage A–Z	1
Recommended further reading	181
Background reading and resources	183
Basic terminology: a guide	189
A–Z text index	197
Acknowledgements	205
About the author	206

INTRODUCTION

There's a vast and confusing range of books about grammar and usage on the market. You could probably go a fair way to filling the Meteor Crater in Arizona with them. Then there are a zillion websites talking about good grammar and bad grammar, and a squillion million internet videos of people leaping up and down in front of whiteboards teaching grammar to anyone with the patience to watch them. It is quite natural for native speakers of all varieties of English to feel unsure of or have doubts about the grammar of their language, be it British, American, Nigerian or Indian. This is nothing to be ashamed of or to feel guilty about. Uncertainty about grammar is not your dark secret: welcome to the world.

So, what is 'good' when it comes to grammar and usage? Shakespeare infamously used a number of what we now call double comparatives and double superlatives such as more hotter, more worse and most bravest, and, of course, what is considered 'good' changes over time. Some things which were considered wrong only a few decades ago are now in use by almost everyone, and viceversa. My aim in this book is to help you feel comfortable with what is widely accepted as standard usage at this time - and, I hope, to entertain you on the way. Things are not always 100% clear-cut, so be prepared to go away with decisions to make and something to think about, rather than always being dished up truths and certainties, which are likely to be untruths and uncertainties or, if they aren't already, may well be so a few years from now.

What is a field guide to grammar?

Grammarians are specialists who try to observe and describe how we typically speak and write. Some grammarians tell you how you should use the language in order to be correct; they are like doctors who prescribe medicines to keep us in good health. Grammars that state what is correct and what is not correct are prescriptive grammars. Grammars that simply describe how people use the language without making any value judgements about good or bad grammar are descriptive grammars. This field guide uses a mixture of both.

Some grammarians get their grammar from past grammars that have been published and then just update them. Sometimes they add a dose of introspection, bits of grammar they were taught in school and brainwaves they get while pondering on the subject. These methods can result in odd, dotty or even downright erroneous versions of grammar.

The armchair grammarian

A more reliable method – and the method I use – is to observe how people use grammar and to make field notes. You do this by reading books, newspapers, letters, websites, blogs, emails, etc., listening to radio and TV, and shamelessly eavesdropping on people's conversations in public spaces. If you gather enough field notes on a particular point of grammar, you can start to craft a

useful statement about current usage. Field notes have a long and respectable history in the study of language. This book uses a lot of fieldwork, though I've never bugged anyone's conversations or read their private diaries, even when they've left them open on the table in the hope that someone will read them. So this book is a field guide. As such, you will notice the letters *Fn* in the margins from time to time. This annotates a field note.

The fieldworker-grammarian

To back up my notes, I have consulted the 100-million-word British National Corpus, which has written texts and transcripts of spoken language in it. Likewise, the 14-million-word Written and Spoken Open American National Corpus has been an invaluable source of evidence. And then on top of that, I've read scores of academic papers and books about different aspects of English and different varieties of English around the world. Like every other grammarian, I can't know everything about everything so I check if my field notes and observations are simply oddities and idiosyncrasies, or whether they really are evidence of widespread usage, as shown in corpora and recorded in other scholars'

published research. I then try to distil my years of observations and corpus research into straightforward guidelines and clear examples that I hope you will find to be both informative and enjoyable, and which illustrate how people actually use the language, as opposed to how we think they do or ought to do. What matters is that you should make your own choices, based on the evidence of current usage and what is appropriate in a given situation.

Why do we need a guide to grammar?

In 2020 and 2021, the world became gripped by the coronavirus pandemic and school buildings were shut down in many countries, leaving parents, carers and guardians ill-prepared for the situation of learning at home which had been thrust upon them. I met frustrated parents who were finding it really difficult to help their children because they had never been taught English grammar when they were young. They felt themselves to be part of the 'lost generation' of the latter part of the twentieth century when, in a number of English-speaking countries, grammar was no longer taught explicitly. You might be one of them.

The neglect of grammar was partly understandable, since the grammar taught up to the 1960s and 1970s was often mind-numbingly dull, abstract and formal, full of bewildering Latin terminology and all about rules and not breaking them, except when there were exceptions, which made things even more confusing. For some people, trigonometry and the theory of relativity were much easier to digest. Grammar has made a comeback since the turn of the millennium, the pendulum has swung the other way, and now, in England, for example, primary school children are expected to be familiar with grammatical terminology, including the infamous 'fronted adverbial' that has generated so much controversy in the UK media. I hope this book will help you if you are a member of the lost generation struggling to get to grips with standard English, and that your seven-year-old won't shame you.

HOW TO USE THIS BOOK

You can just read it from cover to cover if you wish and if you've got the time. There is a table of contents at the beginning of the book and the whole book is organized A–Z and has many cross-references, so you have various ways into it. You can read the explanations or just enjoy the field notes, which are annotated with a line and the abbreviation *Fn*. If you're unfamiliar with grammar terms and basic parts of speech, I suggest starting with the guide to Basic Terminology at the back of the book.

MOVE A SET BEET OF THE BEKEN

and the first of the second The second s

GRAMMAR AND USAGE A-Z

Aa

AAPA

English doesn't have many words beginning with a double A, but this one came to the rescue. It is an Urdu word that has made it into the prestigious *Oxford English Dictionary*. It means an older sister and it's also used as a form of address to other older women. It is a good example of how words from across the world become integrated into English, in this case from the Indian sub-continent.

See INDIAN ENGLISH, LOAN WORDS

ABBREVIATIONS

There is probably now a greater need than ever to shorten words when so much of our communication is through finger-and-thumb jabbing on phones and tablets. Most abbreviations are transparent, though some are from Latin, such as e.g. (exempli gratia – for example), i.e. (id est – that is), N.B. (nota bene – please note), cf. (confer – compare).

One choice you have to make is whether to punctuate abbreviations. Full stops / periods are generally used more in American English than in British English in abbreviations such as *a.m.*, *p.m.*, and in titles such as *Dr.*, *Ms.* and *Mr.* Names of companies and other institutions, especially in their advertisements and logos, usually don't use punctuation (BA – British Airways; CIA – Central Intelligence Agency).

Old newsreels from the 1950s often show British television cameras with B.B.C. proudly emblazoned on their side, but nowadays it is always just BBC (British Broadcasting Corporation).

Texting and social media posting has brought us into a whole new world of abbreviations: LOL (laugh out loud), IMHO (in my humble opinion), TBH (to be honest), BTW (by the way) are just a few of them.

Tip: TBH, IMHO, you should perhaps be careful not to use them in more formal situations.

See FULL STOP, PERIOD

ACCEPT and EXCEPT

It's perhaps surprising, in this age of tyrannical automatic spell-checkers and grammar-checkers, to find so many web pages dedicated to explaining the difference between *accept* and *except*, and so many people posting questions online about the difference between them and how to use them. But grammar-checkers often get it wrong and spell-checkers are sometimes too clever for their own good, so, just for the avoidance of doubt: *accept* is a verb which means to receive, agree or say yes to something, *except* is a preposition or conjunction meaning 'not including'. The problem is that they can sound the same in everyday informal speaking, so they get mixed up in people's minds.

I am proud to *accept* this award on behalf of my teammates. (to receive)

Everyone *except* Maya looked happy. (Maya was the one person not happy)

Except with for is usually followed by nouns or noun-equivalents.

Except for a small minority, everyone voted for the changes to the rules.

In times past, when school grammar textbooks laid down the law, everyone had to accept the rules... except, of course, where there were exceptions.

ACCOMMODATION

Note the spelling: -cc--mm-. Traditionally, British English treats this as a mass (uncountable) noun, so it is not used in the plural.

They have some wonderful *accommodation* for students on campus these days, not like when I was at university.

However, American English and some other world varieties of English have long been happy with plural *accommodations* in sentences like the above and you'll occasionally see and hear it in British English too.

ACROSS

There is a journalistic use of this which has become common in British English in recent years, meaning 'up to date with', as in:

Stay tuned. Our Rome correspondent will be keeping us *across* that story in the coming hours.

ADJECTIVE

See BASIC TERMINOLOGY: A GUIDE

ADVERBIALS

What adverbials do in clauses

Primary school teachers will be familiar with the problems of teaching grammar to 8–11-year-olds and struggling with the prescriptions of the official curriculum. In the English National Curriculum, this includes teaching children about adverbials.

During the pandemic home-schooling months of 2020, a number of parents told me they too were struggling with the concept of adverbials, something the 30–50 age group say they were never taught at school. BBC Radio 4's *Today* devoted a discussion to adverbials on 29 January 2021; adverbials seemed to be the subject of a media moral panic.

Basically, English clauses consist of various components. There are subjects (the 'doers' of actions, the 'agents'), verbs (the actions, states and processes the agents engage in), objects (the people and things acted upon, the 'receivers') and adverbials (the circumstances surrounding actions and events). Adverbials fill in the information about how, when, where, why things are done or happen, the degree to which they are done, and so on.

Here are some simple examples.

S	V	0	A	COMMENT
I	sold	my car	last week.	tells us when
It	happened		so quickly.	tells us how
They	built	a house	on the edge of the village.	tells us where
It	offended	her	greatly.	tells us to what degree

Adverbials are often prepositional phrases, i.e. phrases that begin with prepositions, such as on Monday, in the corner, over the bridge, at six o'clock. But they can also be single adverbs playing the role of adverbials in the clause, such as carefully, suddenly, greatly, upstairs, yesterday. In some grammars, clauses starting with -ing or a preposition + -ing are called adverbial clauses and are treated as adverbials:

Taking great care not to be seen, she removed the money from the envelope.

Fronted adverbials

Adverbials can be quite mobile, occupying different positions in clauses. In the table of examples, they were all at the end, but often they are brought to the beginning for emphasis, contrast, or special focus. These are called fronted adverbials.

Suddenly, there was a loud bang.

On the ground floor there are three reception rooms and a large kitchen-diner. *Upstairs* there are three bedrooms and a family bathroom.

Carefully and with some trepidation, they stepped on to the rope bridge.

Fronted adverbials have been a great source of public debate and controversy in the UK, with some questioning the wisdom of teaching such terminology to very young children.

Early years education

ADVERBS (WELL, SUDDENLY)

Adverbs are a very versatile class of word. Their typical role is to add information about how, where, when, to what extent or under what circumstances things happen. They can also add to the meaning of adjectives.

Most adverbs end in -ly (e.g. slowly, beautifully, badly), though some everyday adverbs do not (well, fast, better, worse, hard [as in work hard], inside, etc.). The following are non-standard:

It all happened very *sudden*. (= suddenly)
She did really *good* in her exams. (= well)

Norman Blake's 2004 book, *Shakespeare's Non-Standard English*, has a long list of adjectives used as adverbs (e.g. *thou didst it excellent* [modern usage: *excellently*], from *Taming of the Shrew*).

I grew up in South Wales, where adverbs without -ly were

considered as normal as being able to sing in harmony. Our national poet, Dylan Thomas, famously referred to the boys dreaming wicked in his immortal Under Milk Wood.

See HARDLY AND HARD, RIGHT(LY), TIGHTLY, WRONG(LY)

AFFECT or EFFECT

Affect is a verb meaning to influence someone or something.

Solar flares can affect radio communications on earth.

We were deeply affected by the sad news.

A complication comes with *effect*. As a noun, its meaning is related to the verb *affect* and it means 'influence or result'.

The effects of the storm were felt over a large area.

Did that cough medicine you bought have any effect?

It's also used in the phrase special effects.

That movie had some amazing special effects.

Effect can also be used as a verb meaning 'to achieve' or 'bring about', but it's rather formal and its use as a verb is thousands of times less frequent than its use as a noun.

The National Executive has *effected* some basic changes in the party structure.

The summit participants signed an agreement designed to *effect* widespread reforms to climate regulation.

AGREEMENT (CONCORD)

Subject-verb concord (I work, she works)

This is basically about making sure the subject and verb don't clash in terms of number.

Except for the verb *to be*, English verbs are straightforward in the present tense, unlike heavily inflected languages, where verbs can have lots of complicated endings. All you need to do is add -s (or -es) when you refer to a third person singular entity (i.e. not *I*, you we or they).

He works for a software company and his wife runs a big charity organization.

My dad watches all kinds of sport on TV but he never does any himself.

When the subject is a plural noun or pronoun, no -s is used:

My friends all live miles away.

We never work after five o'clock.

Nouns that are always plural (politics, economics)

Some nouns are always plural, for example the names of many academic disciplines (*economics*, *politics*, *physics*). These are used with a singular verb:

Quantum mechanics is beyond me. I think you need a brain the size of a planet to understand it all.

Politics is a popular subject at universities these days.

However, when *politics* refers to a person's ideology or attitudes, it is generally used with a plural verb:

Her politics are very right wing. I was surprised.

Fn Ben Jonson, in his The English Grammar of 1640, Made by Ben Jonson for the benefit of all Strangers out of his observation of the English Language now spoken and in use, tackles the issue of agreement with always-plural nouns, reminding us that there's not much new under the sun:

In this exception of number, the verb sometime agreeth not with the governing noun of the plural number, as it should, but with the noun governed: as Riches is a thing oft-times more hurtful than profitable to the owners.

Riches are a thing most people can only dream of would be the usual form nowadays.

Subjects linked by and (Harun and his brother were there)

When subjects are linked by *and*, be careful not to be fooled by a singular noun before the verb:

Harun and his brother was there. (non-standard)

Harun and his brother were there. (standard)

Just recently, a nutritionist interviewed on the BBC in the UK, commenting on dubious health claims made about certain food products, said:

Nutritional and health claims is very important.

The verb should be plural (*are very important*) but the speaker was probably thinking of nutritional and health claims taken

together as one important issue, so psychologically just a single idea. This kind of psychological concord is more common than one might expect, and you may want to keep an eye out for it in your own speaking and writing so that you don't do it in inappropriate contexts, especially more formal ones – most people won't even notice it in everyday social conversation.

When the subjects are linked by expressions like *along with*, *in conjunction with*, *in collaboration with* and *as well as*, the main subject (underlined) determines whether the verb is singular or plural:

Jim. along with his cousin, runs a small software company.

The two sisters, in collaboration with their younger brother, *make* documentaries for TV.

Complex subjects (the risk of infections, pressures on the living wage)

Complications arise when the subject is a complex phrase with a mix of singular and plural elements. Here are two recently heard examples from TV and radio that are typical of the problem that arises.

We are redefining what the value of things are.

When too many hospital beds are occupied, the risk of infections increase.

I asked him a minute or two ago how the state of talks are at the moment.

People often get confused by the nearest noun to the verb, in the first example the plural *things*, in the second example the plural *infections*, and in the third the plural *talks*, so these speakers have made the verb plural. But the main nouns in the underlined phrases (the headwords as they're sometimes called) are *value*, *risk* and *state*; the phrases of *things*, of *infections* and of *talks* simply specify what kind of value, what kind of risk and what specific state we're talking about. *Value*, *risk* and *state* are all singular, so the verb should be *is* in all cases, not *are*.

We are redefining what the value of things is.

When too many hospital beds are occupied, <u>the risk</u> of infections increases.

I asked him a minute or two ago how <u>the state</u> of talks is at the moment.

Another recent, similar UK BBC radio example in a discussion about the European Union was:

The unity of the 27 member states are important.

Unity is singular, so the verb should be is, not are.

The next example also comes from a flagship BBC Radio 4 (UK) news broadcast. Here the opposite is the case and the verb should be *are*, not *is*.

Pressures on the living wage is only going to increase.

It is likely that the nearby singular noun wage is causing interference; it's also possible that the speaker is thinking of pressures on the living wage as one single issue.

Fn Problems with concord are common. You'll hear them regularly in the media even from so-called highly educated speakers and they are endemic in business letters and emails.

Here's a (slightly disguised) example from an email I received from a professional person who probably should have known better.

We are confident that the data to which that formula were applied are accurate.

It's the formula that was applied, not the data. So, was is correct, not were, unless the writer was insisting on using a regional dialect which has were as the third person singular past tense of be, which would be odd in such a formal sentence.

Although it is unlikely in this particular case, it could also be an attempt to impress the reader that the writer knows that *data* is the plural form of *datum* (note the plural *are accurate* in the example).

Tip: don't be distracted by the nearest noun to the verb. Look for the main noun in the phrase.

See also AMOUNT OF OR NUMBER OF, DATA

What-clauses as subject (what we need is more money)

The question here concerns sentences like the following.

What you need is more up-to-date software.

What I love *are* those nature documentaries. Some of the photography is amazing.

We can see that, in general, the verb is singular or plural depending on what follows. However, what follows can also be viewed as a single event or idea, even though there's a plural noun involved.

What we're seeing is more and more people doing all their business on mobile devices rather than on desktops.

A singular verb (is) or a plural verb (are) would both be correct in this last example.

See also CLEFT SENTENCES

Agreement with either ... or, neither ... nor, both ... and

With either ... or and neither ... nor, use a singular verb. These expressions separate out the two elements singularly.

<u>Either Eilish or Promise</u> *pops* in to see her every day to make sure she's all right.

<u>Neither he nor his partner</u> *speaks* Chinese, so they have to hope their clients have good English.

With both ... and, use a plural verb. Here, the two elements are involved in the same event.

Both Ali and Saikat are keen to join the group. What shall I tell them?

This is a convention that is often disregarded, so don't be surprised to find plural verbs in all these cases.

Agreement with neither of and none of

In more formal writing or speaking, *neither of* is generally used with a singular verb.

I offered Karen and Leo tickets for the show but neither of them wants to go.

But just the other day, a friend said about two people:

Neither of them seem to know what's going on.

I don't think anyone would notice this in speech, apart from tiresome people like me who have one ear that listens to what people are saying and the other ear to how they say it.

None of was traditionally held to be singular ('not one of') and so should take a singular verb, but that rule is widely ignored when it refers to a plural group of people or things, except in formal speaking and writing.

None of the stolen cars *was* ever recovered. (formal)

None of my friends ever *go* to church. (most frequently said)

Agreement with words like majority, government, army

This rather depends on how you look at groups of people and things, whether as one single mass or as made up of separate, individual entities.

The army has had its budget cut. (a single mass)

The army *are* furious about the new budget cuts. (a collective of individuals)

All the government *are* basically right wing. (a collective of individuals)
The government *is* split over the fracking issue. (a single mass)

Here are two UK BBC radio examples:

The Metropolitan Police has apologized to [name removed]. (the police in London seen as a single body)

Downing Street *are* listening. (collective of officials who work with the UK Prime Minister in the PM's London house)

The next one is also from BBC radio, by the distinguished British broadcaster John Humphrys, himself author of a well-received book on English usage:1

A body that represents pharmacists say that funding rates ...[etc.]

Here, the idea of a *body* being composed of a set of individuals has produced what would jar on many an ear and which looks slightly odd when written down. And that's the point: real-time speaking is full of things that might not be appropriate in writing. When we write, we can give more time and thought to our choices.

Purists may not like what I've written in this section, but unless you're in deep denial, you'll hear both types of agreement. Choose what sounds best for the situation.

See also AMOUNT OF OR NUMBER OF, DATA, MEDIA, REFLEXIVE PRONOUNS (MYSELF, YOURSELF)

AHEAD OF

No journalist or media commentator seems capable any more of using words like *before* or *prior to*, and instead most use *ahead of* wherever and whenever they can. When it means 'leading up to', or 'earlier / nearer than expected', it makes sense to ordinary listeners and readers:

Informal talks are being held *ahead of* the Paris summit next week.

¹ Humphrys, J. (2005) Lost for Words: The Mangling and Manipulating of the English Language. London: Hodder & Stoughton.

The bridge was completed a month ahead of schedule.

When it is used as a journalistic piece of jargon, it can sometimes seem affected.

Sometimes publishers pay authors an advance *ahead of* publication. (equally good: before publication / prior to publication)

I don't think I've heard any ordinary people use it in the journalistic-jargon way in everyday language.

ALL and ALL OF

Both all and all of can be followed by the definite article (the), a possessive determiner (my, your, his, her, its, our, their), a demonstrative determiner (this, that, these, those) or a noun phrase (Freda's books, the cars). All of is by far the less frequent of the two:

All (of) our cabbages were eaten by slugs.

They invited *all (of)* Kayo's relatives to the surprise birthday party. You can have *all (of)* these old books here; we were just going to throw them out.

ALL RIGHT or ALRIGHT

Traditionalists think alright is somewhat non-standard; Fowler's 1926 A Dictionary of Modern English Usage said it should always be written as two words, all right. Fowler's influence stretched over many decades in the UK and beyond, and some still stick to Fowler's original rule. But don't worry about it. When using it to mean 'okay', it doesn't matter which form you use. But of course, if you mean 'all correct', then it is indeed written as two words:

They were difficult sums. Well done, you got them all right.

ALL TOGETHER or ALTOGETHER

All together refers to a group of people or things in one place.

Are you all together or do you want separate bills? (in a group)

Altogether means 'totally / completely' or 'all things considered'.

That comes to 187 pounds *altogether.* How would you like to pay? (in total)

It was *altogether* the craziest idea I've ever heard. (all things considered)

ALTERNATE or ALTERNATIVE

American English uses *alternate* as an adjective where British English prefers *alternative*. Here's the conventional British usage:

You can drive into the city on *alternate* weekdays, depending on your number-plate. (every other weekday)

They were renovating the place so we had to find an *alternative* venue. (a different one to use instead)

American English speakers typically say *alternate venue* in the second example. As always, it is worth bearing in mind that American usage is constantly being imported into British usage. Neither usage is more correct than the other.

A LOT and ALOT

Remember to write a space between a and lot:

A lot of people go to Croatia for their holidays these days. (Not alot)

See also LOTS OF

AMERICAN and BRITISH ENGLISH

American influence on British English

Some people consider the influence of American English on British English to be an abomination and the term *Americanism* is sometimes said with the nose turned slightly upward. Not only is this disrespectful, since no variety of any language is more valid than any other, but American English is often highly creative and enriches the international English repertoire. American English also tends to dominate in global media and popular culture, giving it huge power and influence.

Some aspects of present-day American English have a long history and reflect the British English of former times. Words and grammar that are sometimes thought of as new, trendy or sloppy American imports often turn out to be older than, or as old as, current British English forms. The use of through, as in Monday through Friday (British English is generally Monday to Friday), is attested back to the end of the 18th century. American usage that allows utterances such as real good instead of really good has its origins in Scottish English. The valedictory phrase Enjoy!, now quite common when addressed to one who is about to embark upon a potentially pleasant experience, is often thought of as an American import. It is often seen as representing a change from a transitive verb that must have an object (enjoy your holiday, enjoy yourself) to an intransitive verb that doesn't need one. In fact, intransitive uses of the verb to enjoy go back hundreds of years. Similarly, the American use of pled instead of British pleaded, as in She pled guilty in court, goes back to at least the 16th century.

Transportation is a word with a long history also going back to the 16th century. However, British English preferred to refer to public transport, while American English preferred public

transportation. More and more now, we hear public transportation in British English, especially in media reports and interviews.

Scots and Irish influences on the evolution of American English were significant historically and some examples of American English grammar reflect those influences, for example the dialect use of *whenever* instead of *when* in sentences such as *Whenever I was a child, we lived in Georgia*, heard in some southern US states, and frequently heard in Northern Ireland.

American English grammar and usage influencing British English and global English is often just a case of 'bringing it all back home'.

American and British grammar: some current differences

There are some differences between conventional standard British English grammar and standard American English grammar that you may come across. Here are some examples. Once again, these are in constant flux and you will hear both versions in British English and sometimes both in American:

BRITISH	AMERICAN
at the weekend	on the weekend
be in a team	be on a team
I haven't seen her for 10 years	I haven't seen her in 10 years
Have they left already?	Did they leave already?
Have you got a pen?	Do you have a pen?
He fitted the profile perfectly	He fit the profile perfectly
We'd got back late	We'd gotten back late
A: I found my keys	A: I found my keys
B: Did you?	B: You did?

(Continued)

BRITISH	AMERICAN
The deal is likely to end next year	The deal will likely end next year
We would love you to do some short videos	We would love for you to do some short videos
I didn't mean it to happen that way	I didn't mean for it to happen that way

Just a couple of years ago, while I was browsing in a shop that was in the midst of its post-Christmas sale, a young sales assistant told me that the jeans I was interested in were 'not on sale'. I repressed my instinct to reply, 'Oh, well, in that case no-one can buy them'. British English traditionally would have demanded not in the sale in this situation; on sale meant 'available for anyone to buy' (e.g. tickets are on sale now). In American usage on sale also refers to goods at a reduced price, and this has clearly worked its way into usage on the British side of the Atlantic.

American influences: phrasal verbs

A number of phrasal verbs (i.e. verbs followed by particles such as *up*, *off*, *over*) have taken on new meanings and / or have become more frequent in recent years, thanks to social media and general media usage, and some verbs which never needed a particle in British English are now regularly heard with a particle or a particle-based expression. These have generally come from American usage. Here are some examples:

VERB	RECENT PHRASAL USES / MEANINGS
Listen!	Listen up!
check sth	check sth out
put oneself out	put oneself out (there) – increase one's public profile, socialize more

VERB	RECENT PHRASAL USES / MEANINGS
Wait!	Wait up!
double down on	strengthen / re-emphasize
call out	challenge, condemn, expose wrong-doing
push back	reject, react negatively against sth or postpone
reach out to	contact sb or ask them to do sth
roll out	extend or distribute sth over a wider area or over a period of time
roll back	reduce to an earlier level (e.g. shop prices)

A recent example on BBC radio was a commentator who said the UK Prime Minister Boris Johnson (at the time of writing) was *doubling down on levelling up*, i.e. reinforcing his election commitment to remove social inequalities. Another recent news report included the following:

The W.H.O. walked back an earlier assertion that asymptomatic transmission of the coronavirus is 'very rare,' saying it was a 'misunderstanding.' (New York Times, 9 June 2020)

These verbs and others like them have also generated nouns, most notable being the universal use of *lockdown* to refer to the imposition of social and economic restrictions. *Unlockdown*, referring to easing of such restrictions, was also heard on the BBC in 2020, both as a verb and as a noun, and *an uptick* seems to have become the standard alternative to *a rise* or *an increase* when referring to pandemic statistics.

Most of these words and phrases circulate mainly in media, business and political circles and don't feature in the everyday conversation of most ordinary people.

See also LOCKDOWN

American influences: social routines

In former times, an informal British English greeting in the street was *Hi!* This has morphed into what one hears more and more now: the American *Hey!* It's often then followed by a social enquiry such as *How you doin'?* or *How are you guys?*, which then gets the reply *I'm / We're good!*, replacing the traditional *I'm / We're (very) well, thank you. Good* is lengthened and given a high-falling intonation, and you can almost hear the exclamation mark. Do such changes matter, or presage the imminent demise of polite society? Most certainly not. Grammar and social routines change and evolve.

In 2011, the BBC online *Magazine* posted a list of 50 Americanisms that irritate and infuriate speakers of British English. It included some mentioned in this book. It is an entertaining and informative read (https://www.bbc.co.uk/news/magazine-14201796).

Research suggests Brits get mildly irritated by Americanisms.

American influences: pronunciation

Because of America's influence on global media and culture, some words which had a conventional British English pronunciation (or which alternated between the two pronunciations given here) have shifted in recent years towards their American equivalents. Examples include: research (Br), research (Am), dispute (Br), dispute (Am), Baghdad (Br), Baghdad (Am). The first syllable of leverage rhymes with leave in British English, but it is being increasingly replaced by the American pronunciation, which rhymes with beverage. And schedule with a sh-sound is definitely fighting a losing battle against schedule with a sk-sound.

You are nowadays likely to hear *enclave* pronounced in the broadcast media both in its traditional British English way (enclave, where *en*-rhymes with *when*) and with its American English pronunciation (on-clave, where *on*-rhymes with *gone*, or ong-clave with a touch of pseudo-French nasality).

A young British-English-speaking waiter recently told me a dish contained *basil* (which he pronounced as rhyming with *hazel*, the American pronunciation – the British pronunciation rhymes with *frazzle*). Basil is a herb: Brits say *herb* with the *h*- pronounced; Americans say 'erb.

And watch out for *airplane* rather than *aeroplane*; this may be thanks to smart phones and tablets offering the option of 'airplane mode'.

See also ACCOMMODATION, AROUND AND ROUND, ALTERNATE OR ALTERNATIVE, BRITISHISMS, -CE OR -SE, NOUNS, VERB, GET, LIKELY, SHALL AND WILL

AMOUNT OF or NUMBER OF

This seems to be changing, but here is the traditional view.

Traditionally, *amount of* is used with nouns we don't normally use in the plural (e.g. *furniture*, *information*, *rice*, *money*, *equipment*). They are uncountable or mass nouns.

That's a huge amount of rice for three people.

It's not worth spending a great amount of money on it.

Number of was traditionally used for nouns in the plural.

It's happened a number of times to people I know.

The number of deaths and injuries has tripled over the last ten years.

However, you will often see and hear examples like these, and often with a plural verb.

The amount of cases of identity fraud have increased a lot in the last few years.

This use of *amount of* with a plural noun more than doubled in frequency between 1994 and 2014, based on the evidence of the British National Corpus.

It's up to you how concerned you're prepared to get over this, but always remember that people may judge you on what they consider to be correct or 'proper' grammar, and that what goes unnoticed in speaking can often stick out like a sore thumb in writing.

Subject-verb agreement with *number* of is worthy of note here. The expression *a number* of takes a plural verb (similar to *a lot of* or *plenty of*):

A number of cases of internet bullying have led to tragic consequences.

A number of is often used with there are, even though a number is singular:

There are a number of things we need to discuss.

The number of takes a singular verb:

The number of cases of bullying on the internet has increased dramatically.

However, a UK Times Radio commentator in 2021, reporting on the incidence of coronavirus infections, said:

The number of cases are increasing.

This is an example of how the nearest noun (cases) can influence a speaker's choice of agreement.

See also AGREEMENT (CONCORD)

ANACOLUTHIA

No, it's not a Russian princess or a novel by Tolstoy. It means starting off a grammatical structure in one way then wandering off into a different structure before finishing the sentence.

This sort of thing can easily be a slip of the tongue that no-one will notice in real-time speaking, but one that always made me smile was the announcement that advised passengers before take-off on a well-known Europe-based budget airline:

Use of laptop computers may not be used till the fasten seatbelt sign has been switched off.

It was a recorded message that probably took a whole committee weeks to come up with. Have you ever tried 'using the use of' a laptop?

Anyway, the airline mended its ways, laptops increasingly became overtaken by tablets and smart phones and you won't hear that one any more.

ANOTHER / A WHOLE NOTHER

While English uses lots of prefixes and suffixes, it only rarely drops other words into the middle of a word (it happens when you say something like *fan-flippin'-tastic*, or *abso-bloody-lutely*). What happens with *another* is illustrated in the following, heard recently on TV:

The electron microscope has given scientists access to *a whole nother* world of research possibilities.

This passes unnoticed in ordinary talk and would probably never appear in writing, but listen out for it and you'll hear it in both British and American English. It's like the process referred to in rhetoric when a compound word is split to let another word into the middle. This is known as *tmesis*, pronounced *t'MEEsis* (/'tmi:sɪs/).

But not so fast! The Merriam-Webster Dictionary tells us that nother is quite an ancient word in its own right, and the expression whole nother goes back to the 19th century, so although it looks as if whole has been dropped into the middle of an-other, it's not quite that simple.

ANY MORE or ANYMORE

Think of *any more* as question and negative equivalents of *some more*. It refers to numbers and quantities.

Do you need any more chairs?

I can't eat any more, thanks, but it was delicious.

Anymore just means 'no longer' or 'any longer'.

They don't make film cameras anymore. They're all digital now.

As usual, there's a complication: don't be surprised to see *any more* written as two words in examples like the one about cameras.

APOSTROPHES

What's an apostrophe and what's it for?

An apostrophe is written as a superscript comma ('). It has two main uses: to indicate possession and to show that something has been shortened. As with some other elements of grammar, conventions shift and change, and emails, texts and tweets are usually less strict about apostrophes.

Possession, close association (Jack's coat, Denmark's economy)

The apostrophe is used to express a relationship of belonging or close association between two people or things, as in *Laura's coat*, *Krishnan's house*, *America's foreign policy*, *Ireland's capital*, *the ship's anchor*.

A plural noun has the apostrophe after the plural -s ending, as in the list of members' names (i.e. all the members), the boys' parents (more than one boy).

Some plurals are irregular; then you just add 's (the children's menu, the men's toilets, a women's refuge).

With regard to names ending in -s, like James or Iglesias or Jones or Phyllis, the same applies – just add 's: James's car, Phyllis's desk.

If you want to be very formal, you can write King James' reign but King James's reign is also okay. However, you'd probably want to say King James's when speaking. Some names like Aristophanes and Archimedes are a bit of a mouthful already and so it's easier to say Aristophanes' and Archimedes' than Aristophanes's or Archimedes's.

Aristophanes' plays are the main source of what we know about the man himself.

What's Archimedes' principle? I've forgotten.

More than one possessor (Nick and Claire's house)

When two people or things are involved in the possession or relation of belonging referring to the same thing, it's only necessary to use one apostrophe.

We're invited to a party at Nick and Claire's house.

Ron Carter and Mike McCarthy's English grammar is in the library.

But you can separate out ownership by using more than one apostrophe in cases where the persons or things possessed are emphasized as separate entities.

Cynan's and Jake's voices are very different but they go together well when they sing.

Apostrophe: noun phrases (the woman in red's husband)

The 's goes at the end of a noun phrase. It's quite okay to say:

He's the woman who chairs our committee's husband.

In writing, especially formal writing, we might prefer an of construction:

He is the husband of the woman who chairs our committee.

Apostrophe: street names, signs, etc.

There is often public controversy about street names, building names and other public signs without 's; there was one recently in Cambridge, UK over *Scholars' Walk*. The Cambridge City Council decided to do away with apostrophes in street names, which caused a rumpus. Mild controversy bubbles up now and then in my home village about our village hall which goes by the somewhat socialist name of *The Peoples Hall*, but the county council's road sign pointing to it has *People's*.

In such cases, it looks as if there should be an apostrophe to show belonging or close association, as in *King George's wife*. If you want an explanation or justification for no apostrophe (N.B. I'm no apologist for Cambridge City Council), then think of a street name or building name like any other proper name or compound noun such as *Buckingham Palace* or *Downing Street*, which don't need 's, despite their close association with famous people and places.

Cambridge City Council backed down and reversed its policy of no-apostrophe street signs. And it's not just Cambridge where this happens. Try doing an internet search on apostrophes in street signs to get an idea of the strong feeling about this. However, there are lots of cases of belonging and possession where English never uses 's and just prefers a compound noun.

The door handle has come off.

I love polishing the piano keys; it sounds like experimental music.

When we refer to people's roles in general, we often do not use an apostrophe:

She was the *team coach* for many years ('team coach' is the title of a job).

When the reference is more specific, an apostrophe may be used:

The *orchestra's leader*, Charles Bencek, was a composer in his own right (the leader belonging to that particular orchestra).

Contractions (I'm Welsh, she's Australian)

The apostrophe shows that something is a contraction (i.e. it has been shortened). Instead of saying *I am Welsh*, we would love to, she is Australian, they have left, he had arrived and so on, when speaking we usually say *I'm Welsh*, we'd love to, she's Australian, they've left, he'd arrived. In more formal writing, it's probably safest to use the long forms.

There's a well-known school exercise-book howler. We often say would've, could've and should've, where the 've has a similar pronunciation to 'of'. But don't write them as would of, could of or should of.

Some other examples of apostrophes indicating missing characters:

fish'n'chips,

o'er the hills,

three o'clock,

'90s music,

I moved here in '98.

Only pedants still write 'phone, 'bye, 'bus (telephone, goodbye, omnibus).

Apostrophe: the 1920s, the 1840's

You don't need to use an apostrophe with the names of decades (the 1980s, the 2010s), but people often use it. The same applies to things like a '70s / 70s haircut, back in the '80s / 80s, but they'd certainly look a bit over the top with two apostrophes: a '70s haircut.

Apostrophe: five minutes' walk

What about expressions such as *It's just five minutes' walk from here?* Conventionally, an apostrophe is used, but you'll see it without plenty of times. You could equally well write *It's just a five-minute walk from here* (which usually has a hyphen).

If the number is just one, 's is used.

It's just an hour's drive from the airport.

Again, you could instead write It's just a one-hour drive from the airport.

Apostrophe: who's and whose

Don't mix up *who's* (who is / who has) and *whose* (to show possession). This is an easy mistake to make and mostly it involves using *who's* when it should be *whose*.

Who's coming to dinner? (who is)

I don't know who's left this scarf here. (who has)

Whose coat is this? (possession)

Daniel, whose father was a seaman, also decided to go to sea. (possession)

Apostrophes and plurals

Apostrophes are not used to indicate a plural. Don't write *She loves banana's*. That usage is often called the greengrocer's apostrophe in the UK: a reference to what one often sees on informally written signs on market stalls.

See also IT'S OR ITS, ONES AND ONE'S, THERE, THERE'S, THEIR, THEIRS, THEY'RE, YOU'RE AND YOUR

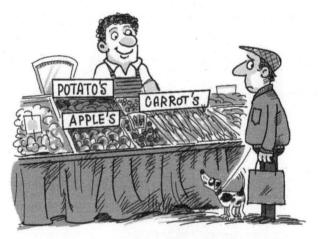

"All these apostrophes are driving me banana's!"

AROUND and ROUND

Both around and round can be used as prepositions or adverbs.

Francis Drake sailed (a) round the world in 1577–1580. (preposition)

I looked (a)round and saw someone running towards me. (adverb)

My grammar-checker doesn't like it if I write *She lives round* the corner from us and wants me to write around the corner.

This could be an American English influence. American English generally prefers around. However, the American rock artist Chuck Berry threw a spanner in the works with his 1958 song Around and Around, but we're told in the opening verse that the joint was goin' round and round, so there we have both forms side by side. On the subject of music, a further complication is that the 19th-century English folksong recorded by the British folk-rock band Steeleye Span in 1975 is most definitely All Around My Hat.

The expression all the year round tends always to prefer round.

ARTICLES (INDEFINITE, DEFINITE)

The indefinite article is a or, before a vowel sound, an. It is used to denote that someone or something belongs to a class of people or things (a teacher, a cat, an egg, a ship, a mistake, an order). The definite article is used to refer to things which the writer / speaker can assume that the reader / listener will be able to interpret (the government, the sun, the kitchen, the garden, the TV remote control).

See also THE AND TO: PRONUNCIATION

AS versus LIKE

One area of debate is whether one should say:

You should do like I did and lodge a formal complaint.

or: You should do as I did and lodge a formal complaint.

It looks like it's going to rain.

or: It looks as if / as though it's going to rain.

Formal versions use *as* when a clause follows (in these examples, *I* did / it's going to rain) and like when a noun or pronoun follows:

Like most people I know, I'm fed up with the commercialism of Christmas.

Like me, you've probably got a lot to complain about.

Rebecca Hughes's 1996 book *English in Speech and Writing*, in which she compares the official written record of the UK Parliament with the words that were actually uttered, has an example of an elected official saying ... it will do the same for politics like it has done with football. The official written record of the debate changed like to as.

AS LONG AS and SO LONG AS

Both of these can mean 'on condition that' or '(only) if'. They are genuine alternatives, so feel free to choose.

You can go out as long as / so long as you're back by ten.

In slightly more formal contexts, *provided / providing (that)* can carry the same meaning.

See also PROVIDED AND PROVIDING (THAT)

AUXILIARY VERB

See BASIC TERMINOLOGY: A GUIDE

Bb

BESIDE or BESIDES

Beside is a preposition meaning 'at the side of' or 'next to'.

Come and sit beside me.

Besides is most often an adverb meaning 'also' or 'what's more'.

I'm too tired to go jogging. Besides, it's raining.

Besides can also be used as a preposition meaning 'apart from' or 'in addition to'.

Besides playing the clarinet, she's pretty good on the piano.

BETWEEN or AMONG

Generations of schoolchildren have been told that *between* should be used with two people or things, and *among* should be used when more than two are involved. Some books on grammar still stick to that. Many users of English happily ignore that rule.

This is the traditional rule.

Share this money between the two of you.

The dog had disappeared *among* the bushes. (several or a lot of bushes)

And here is what you'll often actually hear.

How can you share 100 dollars equally between three people?

If you want to be formal, use the traditional rule. Otherwise, just say what comes naturally.

You can also say *amongst* instead of *among*, but *among* is over five times more commonly used in the British National Corpus than *amongst*; in the written Open American National Corpus, the difference weighted towards *among* is even greater.

BETWEEN YOU AND ME

You often hear people say:

Between you and I, she's not been very well lately.

The standard form would be:

Between you and me, she's not been very well lately.

Between you and I comes from children being told that me is an impolite word or is a sign of bad grammar. That's nonsense. It is also probably a hypercorrection from when people use me as a subject, like in the sentence Sarah and me went to the shop.

Between is a preposition, just like of, to, from, at, among. Prepositions are followed by the object forms of the personal pronouns. The object forms are me, you, him, her, us, them. You wouldn't say This is a present from I; you'd say This is a present from me. You wouldn't say Come and sit between I and Idir; you'd say Come and sit between me and Idir.

But maybe we shouldn't be dogmatic; Shakespeare offers us both versions:

'... all debts are cleared between you and I, ...'

(Merchant of Venice, Act III, scene 2)

'God above deal between thee and me!'

(Macbeth, Act IV, scene 3)

Between you and I has probably achieved the status of a frozen chunk of 'polite' language, one that we retrieve complete from our minds, and language chunks have no internal 'grammar' as far as the user is concerned; they are just ready-made chunks of language. So perhaps the traditional rule doesn't matter anymore. It is your choice.

BORROW, LEND and LOAN

If you borrow something, you receive it. If you lend it, you give it to someone. Both imply a temporary arrangement.

They *borrowed* a lot of money from the bank to build their new house.

I *lent* my drill to my friend who was doing some jobs around the house.

Loan is most commonly used as a noun, but people occasionally use it as a verb in the same way as *lend*, in both British and American English.

A lot of younger people in the UK have student *loans* to pay back. (noun)

I had a wok but I *loaned* it to somebody and they never gave it back. (verb)

BOUGHT and BROUGHT

Bought is the past tense and past participle of buy. Brought is the past tense and past participle of bring.

I bought a pair of shoes last week but they don't fit so I'm taking them back. (buy)

She brought her sister with her to the party. (bring)

Some British English regional dialects use *bought* and *brought* interchangeably. As always, the choice becomes more important in

more formal, high-stakes contexts such as job interviews, public speaking, etc.

BRITISHISMS

The traffic between American English and British English is not entirely one way. American English is very influential globally and has become more and more influential on British English in recent years, thanks to the spread of global media. However, some British expressions have become popular in recent years among users of American English.

Under the headline 'Britishisms and the Britishisation of American English', the BBC website in 2012 (https://www.bbc.co.uk/news/magazine-19670686) listed British expressions that had found their way into American English, such as spot on (accurate, dead right), chattering classes (intellectuals and cultural commentators who are very vocal in expressing liberal opinions), cheeky (rude, unrespectful, but usually in a humorous way) and twee (artificially quaint or perfect), among others, as well as people saying will do (I will do that). Not everyone is happy, and the same web page has two professors disagreeing on whether the British expressions are a positive or negative import. Some words (e.g. snog, a colloquial word for romantic kissing) were put down to the popularity of J. K. Rowling's Harry Potter series.

Another website (https://notoneoffbritishisms.com/) has Google Ngram graphs showing how some Britishisms have entered American English, including *can't be bothered* (do not have the motivation / energy to do something) and, interestingly, *dicey* (meaning potentially dangerous or illegal), which seems to have crossed the Atlantic from Britain in the 1970s and 1980s and is now so popular that it is more frequent in American English than in British English.

This two-way traffic tells us how language can move fairly quickly around the world and how different varieties of English will borrow one another's expressions and donate others to the global pot.

See also AMERICAN AND BRITISH ENGLISH

American English: The Brits have arrived.

Cc

-CE or -SE (PRACTICE, PRACTISE)

This concerns the spelling of some verbs and corresponding noun forms. The British English convention is *-se* for the verb, *-ce* for the noun.

VERB	NOUN	
advise	advice	
license	licence	
practise	practice	

Note also the verb to prophesy and the noun a prophecy.

The compound noun *driving licence* (-ce) in British English is rendered as *driver's license* (-se) in American English, while the noun and verb forms of *practice* are both spelt with a c in American English.

Furthermore, the noun *defence* (-ce, British) is *defense* (-se) in American English.

Offense is many times more frequent than offence in the written Open American National Corpus.

See also SPELLING: -OR AND -OUR

CAN, MAY and MIGHT

The question here is one of formality. Only the most literal-minded (and wrong-headed) pedant would insist that in situations involving requests and permission, *can* refers to ability and *may* to permission.

Can I join you? Yes, of course you can. Pull up a chair.

May is more formal:

[in a meeting, to the Chairperson] May I offer a suggestion, Chair? [Chairperson] Yes, you may.

If you want to be even more formal, might is also available:

Might I propose an adjournment until we have more information?

One of my peer reviewers of this book informs me that children who are taught good table manners often come out with funny things like *May you pass me the butter, please?* This is a kind of hypercorrection (wrongly correcting something on the basis of a rule that does not apply to it) based on the notion that *may* is always more polite.

CAPITAL LETTERS

Capital, or upper case, letters were a lot more commonly used in former times. John Brightland's *A Grammar of the English Tongue* (1711) follows the convention of capitalizing every noun. Brightland obviously disliked the practice but was himself trapped in it (or perhaps was being ironic at the reader's expense):

It is grown customary in Printing, to begin every Substantive* with a Capital, but 'tis unnecessary, and hinders that expressive Beauty and remarkable Distinction intended by the Capitals. (* noun)

In modern English, the first word of a sentence, the names of people and places, titles and initials denoting qualifications are capitalized:

The founder was Mr George Carey, MA, who taught at Yale.

Mount Everest, Lake Titicaca, Asia, Death Valley

The is usually written with a small letter in geographical names and the names of buildings and institutions:

the Thames, the Danube, the Amazon, the Antarctic, the Royal Canadian Mounted Police (RCMP), the Alps, the House of Commons, the White House, the Great Barrier Reef, the British Museum, the CIA

Abbreviations and personal initials use capital letters:

ITV (UK Independent Television), CNN (American Cable News Network), ASMR (Australian Society for Medical Research), P. G. Wodehouse, R. K. Narayan, F. Scott Fitzgerald, J. K. Rowling

Languages and nationalities are capitalized:

Russian, Swahili, Bahasa Malaysia, Gaelic

The first and main words of the titles of books, poems, films, paintings, musical works and so on are normally capitalized, but minor words such as prepositions, conjunctions and articles are usually not in capitals:

A Guest at the Feast, by Colm Tóibín
The Grapes of Wrath by John Steinbeck
Dedham Lock and Mill, by John Constable [painting]
The Wizard of Oz [film]

The names of days, months and important days of the year are capitalized.

Tuesday, April, New Year's Day, Labor Day, Waitangi Day, Spring Bank Holiday

The names of the seasons (spring, summer, autumn, winter) are not capitalized.

The compass references *north*, *south*, *east* and *west* and their corresponding *-ern* forms are not capitalized except when they are part of a proper noun (i.e. place names):

It's a large town in the south of the country.

He lives in Northern Ireland.

Pierre is the capital of South Dakota.

For the names of specific institutions or organizations, a capital letter is used. For references to such organizations in general, a capital letter is not needed:

She studied at Penn State University from 2010–2013.

Is there a university in King's Lynn?

The internet used to be written with a capital letter (the Internet), but the small letter steadily took over as the web became an ordinary part of people's lives.

The pronoun *I* is capitalized (*Will I need a ticket?*), but it is very often written as a small letter in text messages and informal emails:

shall i pick u up at 8:15?

In fact, a recent national newspaper advertisement for the UK charity Barnardo's used a small letter for the pronoun *I* throughout. Very i-catching.

CLAUSE

See BASIC TERMINOLOGY: A GUIDE

CLEFT SENTENCES

See WORD ORDER: CLEFT SENTENCES

See also OBJECT PRONOUNS (IT WAS ME / HIM / ETC. THAT DID IT)

CLICHÉS

Clichés are things that are said so often that they lose their originality and become tedious and sometimes irritating. Nowadays, TV sports or creative arts documentaries cannot seem to survive without the hackneyed line *Following the dream*.

Other clichés include at this moment in time (are there any other kinds of moments?), going forward and at the end of the day, which are heard so often in the media that they have become a sort of brain-dulling opiate.

Your call is important to us usually alerts me to the likelihood of being kept on hold for at least 45 minutes.

Then there is *Let me be clear* or *Let's be clear*, which customarily prefaces an obfuscating response by a politician. Meanwhile, there are tiresome media commentators who refer to almost anything in politics as a *narrative* (or more recently a *trope*). And why every set of events in someone's personal or public life has to be a *journey*, I do not know.

Do try to avoid clichés. Meanwhile, have a nice day.

COLON

A colon (:) can be used to introduce a list of people or things.

There are three types of clothing you must take with you on a hike: waterproofs, extra layers for warmth and headgear of some sort.

The subtitles and sub-headings of books and articles are often preceded by a colon.

McCarthy's Field Guide to Grammar: Natural Usage and Style

In the case of book and article titles and headings, usage varies as to whether the next word after the colon has a capital letter. Sometimes colons are used before quoted speech, especially if it is quite a long speech.

'She looked at him angrily and said: "Over my dead body!"

Colons are often used for times.

The flight departs at 09:20 and arrives at 11:30.

In British English, the first letter after a colon is a capital if it's a proper noun. In American English, the first word after a colon is a capital if it begins a complete sentence.

COMMA

Commas in lists (laptops, tablets and phones)

British English normally follows the convention of a comma after every item in a list except the last one, which usually has *and* before it.

Go into any family home in the evening and you'll find everyone glued to TVs, PCs, laptops, tablets and phones, often without exchanging a word.

In cases where there's another *and* in the environment, it's often helpful to use a comma along with *and* before the final item.

As well as words, there are items like apostrophe 's, plural -(e)s, past tense -ed and present participle -ing, and symbols such as commas, full stops and question marks.

However, American English always prefers a comma before the *and* in a list. It's known as the **Oxford comma** or the serial comma. In the UK, some publishers and organizations ask for Oxford commas to be used, whereas others suggest using them only when omitting them could cause confusion.

Commas with adjectives (a long, blue, silk dress)

When more than one adjective is used before a noun, we normally separate them with a comma after each one except for the final one:

An elegant, long, blue, silk dress

However, when an adjective forms part of a compound noun or is very closely associated with the noun, commas are not used:

We saw a beautiful red kite. (i.e. the bird; not: a beautiful, red kite, which might suggest a kite on a string)

A gorgeous, full-bodied, aromatic Italian red wine

Commas: more than one main clause (she sings and plays the guitar)

When there are two main clauses linked by words like *and*, *but* and *or*, we don't need a comma.

She sings and plays the guitar.

With more than two main clauses, it's just like any list: commas before all but the last clause.

He sings in a choir, he belongs to a chess club, he's a brilliant squash-player and he speaks fluent Norwegian. He makes me feel like a complete waste of space.

You can have a starter and a main course, you can have two starters and no main course but you can't have two main courses. Otherwise, they're pretty flexible.

Comma-splices

A comma-splice is a sentence with two main clauses connected by a comma with no conjunction:

My cousin's coming to stay, he's arriving tomorrow.

Comma-splices are often found in informal writing, but in formal situations, the convention is to use a semicolon or to make two sentences.

My cousin's coming to stay; he's arriving tomorrow.

My cousin's coming to stay. He's arriving tomorrow.

See also HOWEVER

Commas after subordinate clauses (if you're driving, avoid the M25 motorway)

Subordinate clauses are clauses that don't make much sense on their own. They need to be attached to a main clause to make a full sentence or to a context where it's obvious to the listeners / readers what they mean. Examples are clauses starting with *if*, *when*, *as*, *because*, *before*, *after*.

When a subordinate clause comes before the main clause, it's normal to use a comma.

When you've finished, we can go for a walk.

If it makes life simpler, Gregori can book into a B&B.

When a subordinate clause comes after a main clause, we don't need a comma.

Will you look over this email before I send it off? Tell me if there are any grammatical howlers in it.

She bumped into her ex-husband as she was coming out of Victoria Station.

Commas before and after embedded clauses (we could, if you prefer, leave earlier)

Clauses embedded in the middle of other clauses are separated off with commas.

We could, if it is more convenient, bring the meeting forward by a day or two.

Commas and linking words and phrases (it could cost a lot more, however)

It's normal to use commas to separate off linking words and phrases like *however*, *therefore*, *nevertheless*, *on the other hand*, *as a result* and so on.

Families are welcome. However, we cannot allow children to approach the bonfire unless accompanied by a responsible adult.

She's your customer and you've always dealt with her. I will, therefore, respect your decision on how to proceed.

This convention is not always strictly adhered to, especially in emails, blogs, text messages and the like. U can there4 ignore it if u want.

Commas around noun phrases in apposition (Jim, the eldest son, is in prison)

Apposition is when you have two noun phrases referring to the same person or thing. Usage varies, with commas being used in more formal contexts. Sometimes, commas help to clarify things.

My sister Mary worked for years as a librarian. (This doesn't necessarily tell you how many sisters I have and it may not be relevant.)

My sister Mary worked for years as a librarian. My other sister was in the army.

My sister, Mary, was always cleverer than me at school. (The commas suggest I just have one sister.)

If you say these out loud, the commas imply momentary pauses each side of *Mary*.

It's a bit like the section on commas and relative clauses. The commas tend to bracket added information which can be removed without making the sentence cryptic or making it difficult to know who or what is being referred to.

His first novel, The Queen Never Came to Tea, was an immediate hit.

But, as usual, watch out for variations. What matters most is making your meaning clear and unambiguous.

No comma between subject and verb (the person who did it was drunk)

So many people break this convention that I'm probably fighting a losing battle. Here are the kinds of examples I'm referring to. Subjects are underlined.

The person who broke the windows, was a disgruntled exemployee of the firm.

That she knew what was happening all along, is obvious.

Neither of these sentences needs a comma. We would not use a comma after a simpler subject such as *she* or *he* or *Diana Stevens*, so don't use one just because the subjects are long phrases or clauses.

The UK newspaper the *Daily Telegraph*, known for its general conservatism in matters of language, inserted an unnecessary and infelicitous comma between the subject (*literature and the art of writing*) and the verb (*had taught him*) in this comment about HRH Prince Charles, heir to the British throne:

'He suggested literature and the art of writing, had taught him to make sense of the world.'

(Daily Telegraph 21 February 2016)

No comma between be and its complement (the problem is that ...)

A complement is different from an object. Complements come after verbs like be, become, seem, look, smell, taste: she is a lawyer, I've become less tolerant of hypocrites in my old age, it looks / smells / tastes pretty awful. When the complement is a that-clause or an infinitive clause, the temptation is to use a comma before it, but it is unnecessary. Here are two examples of unnecessary commas:

The problem is, that not everyone in the village is on email, especially some older residents. (that-clause)

Their strategy seems to be, to wait until things have settled down a bit. (infinitive clause)

In neither case is a comma necessary. But, as is so often the case, history confounds us. Lindley Murray, in his influential grammar of 1795, tells the reader under 'rule xvii' that a comma *should* be used in sentences with infinitive clauses after *be*:

The most obvious remedy is, to withdraw from all associations with bad men.

Many books from previous centuries are hirsute with commas and other punctuation that would seem excessive today. Some of the commas in this typical extract from Laurence Sterne's *The Life and Opinions of Tristram Shandy, Gentleman* (1759–1767), especially those which accompany dashes, now seem unnecessary:

'I must here inform you, that this servant of my uncle Toby's, who went by the name of Trim, had been a corporal in my uncle's own company,—his real name was James Butler,—but having got the nick-name of Trim, in the regiment, my uncle Toby, unless when he happened to be very angry with him, would never call him by any other name.'

(Chapter V.XXX)

Old grammars and literature are a constant reminder that yesterday's norms are often today's jealously guarded traditions for some, fossils and oddities for others, and tomorrow's howlers.

Two main clauses

In sentences with two main clauses which are closely connected in meaning but which are not linked by words such as *and*, *but* and *or*, we use a semicolon, not a comma, to separate the clauses.

He didn't stay long; he went home after about half an hour.

A lot of people use a comma in such sentences, but in formal writing, a semicolon is probably a safer choice.

See also COMMA-SPLICES

Commas separating off adverbial phrases (I love cakes, especially at teatime)

Adverbial phrases that comment on the whole clause or sentence are often separated off by commas. In speech, there is typically a brief pause where the comma is.

Ideally, classes should be as small as possible, especially in primary schools.

For what it's worth, my inclination would be to cancel the whole thing.

Commas and vocatives: people directly addressed (Julia, come here, please)

When written, the names of people directly addressed are usually separated off by commas.

Please, Richard, don't be offended by what I'm about to tell you. Irene, could you reply to this email for me?

See also RELATIVE CLAUSES (THE GIRL WHO BROKE THE WINDOW), HOWEVER

COMPARE TO and COMPARE WITH

Traditional usage was that *compare to* meant 'to say that something is similar to' or 'to liken'.

She upset him by *comparing* his garden to a jungle. (She was saying his garden was like a jungle.)

Compare with meant simply to examine more than one person or thing to see if there were similarities or differences.

If we *compare* Portuguese *with* Spanish, we see many similarities but enough differences to say they are separate languages.

This traditional rule is not held to hard and fast, especially in the expression *compared to / with*, where both are almost equally common.

Compared to / with my old car, this one is much more comfortable.

If you like the traditional rule, apply it; otherwise, don't worry.

COMPARATIVES (BIGGER, EASIER)

Comparative adjectives and adverbs (bigger, worse, more slowly)

Comparatives are used to compare two people or things or two situations.

Geoff is taller than me.

His latest film is even worse than the last one.

She always speaks more slowly when she's tired.

Who was the better speaker, Jan Cullingworth or Ailsa Ward?

In examples like this last one, where two people are compared, the comparative is the more formally correct.

However, people often use the superlative when comparing two people or things, which, strictly speaking, is used when singling out a person or thing from a group of more than two:

Which is the best knife to cut the bread, this one or the other one?

Which is the better knife would be the traditionally correct form, but it would probably sound too formal in most everyday situations.

There's nothing new in this use of the superlative; it's not some latter-day corruption of the high standards set by the 18th-century prescriptive grammarians. William Bullokar, some 430 years ago, in his *Pamphlet for Grammar*, at the section on comparatives, concedes: ... we English use the superlative also when we compare but two things together. (modernized spelling and orthography)

Note that in *Geoff is taller than me*, above, we say me, not I. If me sticks in your throat, you can use I (or he, she, we, they, as the situation demands) by adding a verb:

Geoff is taller than me / than I am.

He achieved more than her / than she did.

Comparisons with as ... as, not as ... as, not so ... as

As with comparative adjectives and adverbs, the object forms of the personal pronouns are used.

He went to university and his brother's just as clever as him but he didn't want to have to study.

He's not as tall as her.

If your sense of symmetry is offended by the object pronouns, you can salvage your dignity by continuing with a verb:

He's not as tall as she is.

Comparisons with *not so... as* are many times less frequent in British and American corpus data than those with *not as ... as.*

It turned out to be *not so far as* we thought and we were there in less than an hour.

See also SUPERLATIVE, THAT OF

COMPRISE and CONSIST

Consist of and be comprised of are often used interchangeably.

The cultural hub consists of a concert hall, a museum and a café.

The cultural hub is comprised of a concert hall, a museum and a café.

Comprise used in the active voice reverses the order of things compared with *consist*.

The committee consists of ten members.

Ten members comprise the committee.

CONJUNCTIONS

Conjunctions are words which join together (they 'conjoin') words, phrases or clauses. The two main types are coordinating (and, but, or) and subordinating (e.g. because, when, if, unless). The main thing to remember in writing is that the coordinating conjunctions join word to word, phrase to phrase, clause to clause and not a mixture of types:

He runs a small company and works from home. (two clauses)
He runs a small company and from home. (unhappy mix of a
clause and a phrase)

CONTINUOUS and CONTINUAL

Continuous means that something happens without any break or interruption.

It looks better if you can show *continuous* employment on your cv without any unexplained gaps.

Continual means something goes on and on but there may be interruptions or brief intermissions.

Good software is subject to continual updating during its lifetime.

The corresponding adverb forms are continuously and continually.

We worked *continuously* for 12 hours and were exhausted. We didn't even stop for a meal.

I'm *continually* amazed by how many people I see using their phones when driving.

CONTRACTIONS

Contractions are when short forms of verbs are used, as in I'm okay, Joe's here, she'd love it, we've eaten, it isn't ready, they hadn't heard, etc.

They project informality and therefore should be used with caution in formal writing, for example in academic essays. But if you want to project friendliness, they are a good way of using the grammar.

An official information leaflet from the UK Driver and Vehicle Licensing Agency (DVLA to UK residents) laying out the rules pertaining to passing on vehicle tax to a new owner when you sell or give away a vehicle contains can't, it's, you'll, you're, you've and we're. This is clearly designed to make the reader feel comfortable and cared for (before you're taken to court for breaking those very rules) and is to be applauded as an attempt to avoid the stuffiness of much official bureaucracy.

Don't confuse you're (you are) and your (possessive – Is this your pen?).

I hope you're feeling better. (Not your)

Your new job seems to be keeping you busy.

Don't confuse were, we're and where:

They were tired. (Past tense of they are tired.)

We're going out tonight. (Present tense of be: We are going out.)

Where are you working these days? (enquiring about a place)

Fin In case you think this last point is a little obscure, a headline above a reader's letter encouraging cyclists to wear high-visibility clothing during hours of darkness in the UK Cambridge News daily newspaper ran: Where something white at night (2 December 2017).

Finally, remember to use the apostrophe in contractions involving will; otherwise we'll becomes well and, by curious analogy, I'll becomes ill.

See also APOSTROPHE: CONTRACTIONS (I'M WELSH, SHE'S AUSTRALIAN), APOSTROPHE: WHO'S AND WHOSE, THERE, THERE'S, THEIR, THEIRS, THEY'RE, YOU'RE AND YOUR

CONTRIBUTE, DISTRIBUTE (STRESS)

The pronunciation of these varies as to where the stress falls, whether on the middle or beginning of the word.

Stress on the middle of the word:

conTRIBute diSTRIBute

Stress at the beginning of the word:

CONtribute **DIS**tribute

Both pronunciations are widely used and acceptable.

CORPUS / CORPORA

A **corpus** (plural **corpora**) is the name given to a collection of texts stored in a computer. A corpus could be, for example, every issue of *The Washington Post* published over a number of years, or the transcripts of a set of radio or TV broadcasts dealing with a particular subject over a given stretch of time, or all the novels of a famous novelist, a collection of oral story-telling, and so on.

Corpora are extremely useful for linguists. Many dictionaries are now compiled by listing all the words in a big, general, mixed list of texts in any given language. Some of the corpora used for English dictionaries consist of texts adding up to hundreds of millions of words. Using dedicated software, the researchers look at thousands of individual words to see what they mean and how people use them. Corpora are particularly useful for providing answers to controversial issues of grammar, for in a big corpus, we can see how people really apply the rules and conventions, rather than how we might imagine them to use them or how we would like them to use them. And because the observations we get from corpora are based on statistics, for example how frequent or how rare something is in the corpus, we can be more objective.

The computer has never read a grammar book, never been to school, never looked something up on the internet – all it does is count. It has no prejudices about language or anything. But grammarians and dictionary writers still have decisions to make. The corpus does not write usage manuals or reference books; that is where human observation and judgement take over.

In this book I have used corpora to check my observations made in the field. If the corpus bears out what I want to say, I use the information to create the entries as you see them in the book. If the corpus contradicts my observations, I have to

do more fieldwork till I am satisfied that what I say has some evidence to back it up. Corpora of American and British written and spoken English have proved very useful in the compilation of this book.

See BACKGROUND READING AND RESOURCES

COUNTABLE NOUN

See BASIC TERMINOLOGY: A GUIDE

COUNTRIES

This concerns whether we use the definite article (*the*) in front of country names. Conventions have changed over the years and the definite article is now being used less and less. Formerly, people referred to *the Ukraine*, *the Gambia*, *the Lebanon* and one or two other countries in like manner. Most people now say *Ukraine*, *Gambia* and *Lebanon*.

The following have kept a stronger hold on their definite article: the USA (the United States of America), the Netherlands, the Philippines, the Czech Republic, the Democratic Republic of the Congo.

All countries on the United Nations list of member states web page are named without the article, except for *the former Yugoslav Republic of Macedonia*.

And what of *the United Kingdom*, birthplace of this book? I've lost count of the number of times recently I've heard it on the BBC used without the definite article in economic, political and sporting contexts.

CREATIVE WORD-FORMATION

Creative suffixes (Irangate, workaholic)

Suffixes are endings added to words that change their meaning or function. For example, -ment gives us nouns from verbs (e.g. excitement, containment, judgement), while -ful often indicates an adjective (hateful, thankful, beautiful). Some elements of words are used as if they were suffixes, often to great creative and humorous effect. From the word alcoholic, referring to an addiction to alcohol, other types of addiction have been given names. Examples include: shopaholic, workaholic, chocaholic, blogaholic, textaholic, tweetaholic.

Similarly, after the Watergate scandal in the USA in the 1970s, public scandals and controversies are often referred to using *-gate* as a suffix, such as *Climategate*, *Irangate* and recently in the UK when a leading supermarket chain threatened to stop selling the food product Marmite, *Marmitegate*. At the time of writing, *Wikipedia* offers a breathtaking list of *-gate* scandals.

Back formations (liaise, babysit)

English is a wonderfully flexible organism. Words can hop around from one word class to another, they can change their shape like mimic octopuses and can acquire new meanings, constantly evolving to suit their environment.

Back formations are an example of this flexibility. By removing suffixes, or what look like suffixes, new versions of words can be formed. Here are some examples where verbs have been created from nouns:

babysitter – to babysit bulldozer – to bulldoze

curator - to curate

head-hunter - to headhunt

liaison – to liaise proofreader – to proofread

An interesting example of shortening a word that has left the population divided is that some people say *conflab* when they mean an informal chat to resolve some matter, while others prefer *confab*. Both are a shortened form of *confabulation* and the letter *l* seems to have migrated to a position after the *f* in *conflab*. *Confab* has the longer history and is by far the more frequently used of the two, but *conflab* is attested as far back as the mid-19th century.

Conversion (a big ask)

In the case of conversion, a word simply changes to another grammatical class.

That's a big ask. (ask changes from verb to noun)

Text me tomorrow to remind me. (text changes from noun to verb)

Who's going to *chair* the meeting? (*chair* changes from noun to verb)

[TV historian about to put on safety goggles before firing a medieval cannon] Time to *safety* up! (*safety* changes from noun to verb)

Recently, a well-known author of whodunnits referred in a TV interview to a typical twist where the reader thinks they know who committed the foul crime, then suddenly, someone *alibis* the prime suspect. *Alibi* began life as an adverb (from the Latin meaning 'in another place'), then by the mid-18th century it had morphed to a noun and now this latest example sees it used as a verb.

Words can also simply change their meaning or add a new sense to their meaning to adapt to new social and technical realities. A *mouse* was once a rodent, now it's also a gadget for manipulating your computer. In my teens, *hipsters* were trousers that hung from the hip; now they're a super-trendy person.

Clipping (barbie, maths, footy)

Words can be 'clipped' or shortened. American English shortens mathematics to math (British English keeps the final 's' – maths); because is routinely shortened to cos in informal speaking and texting. Burger, mike (microphone) and bike are common examples. Australian English is particularly rich in this respect, with words combining clipping with extra suffixes as in barbie (barbecue), arvo (afternoon), Tassie (Tasmania), Aussie (Australian), footy (football) and rellies (relatives). A more universal example is the clipping of self-portrait and the addition of a suffix in selfie.

Blends (smog, brunch)

English is perpetually creative. Bits of existing words and expressions can blend together to form new words and expressions to respond to new social and environmental conditions, for example smoke + fog = smog, breakfast + lunch = brunch, America + Track = Amtrak.

Fn In the 18th century, the writer Horace Walpole coined the term gloomth (gloom + warmth) to evoke the atmosphere of great Gothic buildings. Lewis Carroll (author of Alice in Wonderland) was very creative, inventing words which included his fabulous creature The Frumious Bandersnatch; he explained frumious as a blend of fuming and furious.

In the late 19th century, the term *electrocute* (*electric* + *execute*) was coined in the USA.

In this century, *Grexit* and *Brexit* (*Greek* + *exit*, *British* + *exit*) were coined to refer to Greece's potential, and the UK's actual, exit from the European Union. Those who supported Brexit became known as *Brexiters* or *Brexiteers*. After the 2016 UK referendum vote to leave the EU, those who had voted to remain in the EU, known as *remainers*, but who continued to be vocal

in their stance against the vote to leave, were branded remoaners (remain + moaners).

While Wi-Fi technology and hot-spots are ubiquitous in the UK, at the time of writing, some rural areas still suffer from slow internet connections and poor or no mobile phone signals. To describe such areas, *not-spots* was coined as an opposite of *hot-spots*.

The viral pandemic of 2020 caused many people to cancel holidays abroad and instead to stay at home or in their own country and enjoy a *staycation* (*stay* + *vacation*).

Other recent blends include: vlog (video + blog), malware (malicious + software), labradoodle (labrador + poodle), cockapoo (cocker spaniel + poodle), webinar (web + seminar).

CRITERION / CRITERIA, PHENOMENON / PHENOMENA

In each case, the -on ending is singular and the -a ending is plural.

An interesting phenomenon / a range of interesting phenomena The single most important criterion / three essential criteria

You will often hear the plural forms (*criteria*, *phenomena*) used for singular and plural, and it may be that the singular forms are now an endangered species.

Dd

DASHES

A dash is written like a long hyphen – use it with care. It suggests a pause (if you read the previous sentence out loud, you will probably pause briefly and take a breath at the dash).

Dashes can be used like brackets, to put something into parenthesis or apposition:

Dublin – Ireland's bustling capital city – became a popular destination for stag and hen parties.

In British English, a long dash called an en rule is used, with a space on either side. However, in US English and British legal text, a slightly longer dash called an em rule is used, without a space on either side.

A dash can also carry the meaning 'from-to' with days, dates and times:

Open Mon-Fri, 09:00-17:00

Headings and sub-headings often use dashes when the main text continues on the same line:

Tuesday 17 July – pick up your vehicle from our main depot at the airport

Tuesday 24 July – return your vehicle to our city depot in Bristol

DATA

Dictionaries sometimes give *day-ta* as the pronunciation; sometimes they give both *day-ta* and *daa-ta*. During my academic career, I heard *day-ta* more often among my British colleagues. The American *Merriam-Webster Online Dictionary* gives three slightly different pronunciations which can be listened to at the click of a mouse.

Strictly speaking, *data* is a plural noun (singular: *datum*) and the plural is preferred in scientific and academic writing. Some people use a plural verb after it; some use a singular.

The data were checked three times, and each time, minor errors were spotted.

All the data was lost when the hard drive crashed.

A BBC radio commentator, obviously uncertain about the pronunciation, hedged his bets and referred to *dayta* then in the same breath changed it to *daata*. You could almost hear the forward slash between the words. My advice: take your pick.

DEFINITE(LY)

A common error is to write definate and definately.

DETERMINER

See BASIC TERMINOLOGY: A GUIDE

DIFFERENT TO, FROM, THAN

Many a word has been written on this issue. *Different from* is overall the most frequently used of the three alternatives. In the written American corpus consulted for this book, *different from* is 30 times more common than *different to*. In British English writing, the difference is not quite as great (*from* being about nine times more frequent than *to*) but is still big.

The landscape of that part of Turkey is *different from* that of the rest of the country.

Different to is often preferred in speaking, especially in British English, where to is about three times more frequent than from. In American English, the difference between from and to is reduced from 30 to about six times more frequent.

Iris claims it was a positive meeting but that's *different to* what I remember.

Different than is generally considered to be American English; one of Bob Dylan's early songs contained the line I ain't different than anyone (I Shall Be Free No. 10, 1964). However, British English speakers sometimes use different than when it is followed by a clause (underlined here):

He looks very different than when I last saw him. He's aged a lot.

Different from or different to would also fit just as well in this last example.

Fowler, in his A Dictionary of Modern English Usage (1926), dismissed the idea that different could only be followed by from as a 'superstition'.

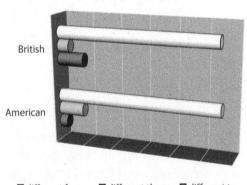

□ different from □ different than □ different to

Different to, from, than in British and American English Source: Google Books Ngram Viewer http://books.google.com/ngrams

DIALECTS AND STANDARD ENGLISH

Dialects are simply different ways of speaking within the same language. Dialects are often seen as inferior or something to be shed as you climb the socio-economic greasy pole, because dialects differ from the most widely accepted standard. Dialects are not inferior to any other way of using language. It just so happens that, because they are often rooted in geographical regions or social groups, they are considered different and non-standard when compared with whatever dialect has achieved the powerful status of nation-wide use in education, literature and the media.

Whenever I mention 'standard' or 'standard forms' in this book, I am talking about majority usage across a wide range of speakers and writers in the United Kingdom, Ireland, North America and occasionally Australia, based on years of researching different computerized corpora of written and spoken English, fieldwork and observation of usage in the media and in the English of people going about their everyday business. Occasionally I also have recourse to commonly accepted standards derived from trustworthy reference grammars. I make no negative value judgements of dialect forms, but I do bring to your attention those that are sometimes infelicitously mixed with standard forms where they clash like non-complementary hues. Non-standard forms should be used as and when appropriate and you should simply become aware of them in your own usage, whether you are a speaker of a 'posh' or 'toff's' dialect or a regional, rural or urban dialect, or one associated with a particular social class or community. The important thing is to know what is and what is not suitable in any given situation and to choose appropriately.

We all speak a dialect – whether it be the standard dialect or a regional one – and many people can swap freely between one and the other. Dialects are badges of identity – they are a symbol of belonging – so wear your badge proudly whenever you feel it is appropriate.

DOUBLE IS (THE THING IS IS ...)

This is a feature that applies to speech. I don't think anyone would write it, but keep your ears open for it. It affects expressions like *the problem / question / thing / trouble is*:

The question *is is*, why should we have to grit our own street when we pay the county council to do it?

The thing is is that it's costing fifty thousand dollars.

This double use of *is* can be considered evidence of 'chunking', where expressions like *the question is* have the status of frozen routines or idioms, with no internal grammar. For the speaker, the first *is* doesn't count as a verb, so the sentence needs a proper verb, which is supplied by the second *is*.

Further evidence of this can be seen in this example from a speaker on the UK BBC Radio 4 *Today* broadcast on 14 January 2017, who, explaining the reason for something, said *the reason being is that* ... Here the verb *be* is already present in *being* and does not need to be repeated.

To the best of my knowledge, the phenomenon was first reported fully in the academic literature in the 1980s, in connection with American, Australian and New Zealand English,² and researchers agree that the two *is* are spoken in quick succession.

The double is may not always be appropriate, especially in very formal situations.

² Bolinger, Dwight L. 1987. The remarkable double is. *English Today* 9: 39–40. McConvell, P. (1988) *To be or double be?* Current changes in the English copula. *Australian Journal of Linguistics* 8 (2): 287–305.

DOUBLE NEGATIVES

Double negatives: when best not to use them (she hasn't got no money)

Although many dialects and international varieties of English are quite happy with sentences like the following ones, the standard varieties which act as a sort of common coinage where English is used generally disapprove of them.

Non-standard / dialectal: I don't want nothing to do with it.

Standard: I don't want anything to do with it.

Non-standard / dialectal: She hasn't got no money.

Standard: She hasn't got any money.

Double negatives for emphasis with adjectives (not unreasonable)

Adjectives can be negated using prefixes like *un-* and *im-* (e.g. *unreasonable*, *impossible*). For stylistic emphasis, these can be used with *not* to create a positive meaning in rather formal contexts.

The demand for a public enquiry is *not un*reasonable, given the circumstances.

If this happens, street riots would be a *not im*plausible consequence.

Other kinds of double negative (she's not here, I don't think)

Some kinds of double negative pass unnoticed in everyday speaking. Here are some types you will hear on a regular basis.

It's worth getting one. They're not that expensive, I don't think.

If we reverse the clauses in the second sentence, one of the negatives disappears.

It's worth getting one. I don't think they're that expensive.

Here's another type you hear quite frequently.

I wouldn't be surprised if they didn't split up. They're always bickering.

A more strictly standard version would be *I wouldn't be surprised* if they split up.

In this next example, A and B are two speakers in conversation.

A: I don't think we'll see much wildlife today.

B: Not without binoculars we won't.

So, two negatives don't always make a positive. The 18th-century grammarian, Robert Lowth, said: *Two negatives in English destroy one another*. Applying that kind of logic to everyday language use can be misleading.

Two negatives don't always make a positive.

DUE TO and OWING TO

People often worry about these two expressions because they can't quite remember what they were taught at school. They only remember that the teacher said it was a ghastly mistake if you used the wrong one. For my generation, that kind of rule belonged to the days when grammar, like television, was only available in black and white. Nowadays, the picture is more nuanced, but for those who want the traditional rule, here it is.

Owing to is a complex prepositional expression which is always followed by a noun phrase.

Owing to the bad weather, the village picnic has been postponed till next weekend.

Due is an adjective that happens to be followed by to.

Due to Covid-19 restrictions, no more than 30 people may attend the event.

It is often used after the verb to be:

The delay was due to a signal failure further down the line.

That's what we were taught at school, but be prepared to hear and see *due to* used in the first example and *owing to* used in the second.

DUNNO, GONNA, GOTTA, WANNA

These forms are shortened versions, respectively, of don't know, going to, got to and want to. In the past they were confined to literary uses when attempting to capture everyday casual speech. While they would be out of place in formal writing, they are very useful in contexts such as text messaging and tweeting as they are both economical and informal.

Listen to UK parliamentary debates (the real, live ones broadcast on radio and TV and online, not the cleaned-up versions in the official record); you will regularly hear Members of Parliament saying *gonna*, though they might never admit to it.

Ee

EACH OTHER and ONE ANOTHER

These are used to refer to reciprocal actions. The conventional rule is that *each other* involves two subjects, while *one another* involves more than two.

Jo and Hilary dislike *each other*. (Jo dislikes Hilary and Hilary dislikes Jo.)

The committee members were always critical of *one another*. (more than two people are involved)

This distinction is often ignored and few people would get on their high horse nowadays if they heard an adult address two squabbling children and say:

Stop it, you two! Be nice to one another!

EITHER and NEITHER

There are two pronunciations: eye-ther and nye-ther (same sound as in *eye* or *sci-fi*) or eether and neether (same sound as is *bee's-knees*). British English tends to prefer the sci-fi versions; American English generally prefers the bee's-knees versions.

Me neither (pronounced in the American way) seems to be becoming more frequent in British English these days. Older generations grew up saying Nor me if someone said I don't like Mondays. Posh speakers grew up saying Nor I. There's a fair

sprinkling of outraged reaction on the internet to *Me either* (*meether*) being used in the same situation, so if you don't want to upset anyone, that's one to avoid.

Anyway, as far as the basic pronunciation goes, take your pick. Either will do.

ELDER and ELDEST

See OLDER, ELDER, OLDEST AND ELDEST

ELLIPSIS (POSTMAN BEEN YET?)

Ellipsis means leaving out something that is theoretically considered to be required by the rules of grammar. I say 'theoretically' because, most of the time, people understand one another perfectly well in context even when messages are extremely brief, and do not feel that anything has been 'left out':

Finished? (Have you finished?)

Haven't had time to sort out the plumber yet, sorry. (I haven't had time ... I'm sorry)

You going to the film on Saturday? (Are you going ...?)

Postman been yet? (Has the postman been yet?)

[Two separated lovers, A and B, on the phone]

A: I miss you.

B: And I you. (I miss you)

This kind of ellipsis is often called situational ellipsis because the situation provides enough context for even very short utterances to be fully understood. The less contextual support there is (e.g. in a written document that will be read at a different time and place from when it was created), the more fully elaborated the grammar needs to be.

Sometimes, the sentence itself can provide enough clues by using parallel structures:

The main streets were a blaze of lamps and neon signs, the back streets a labyrinth of dark lanes. (understood to mean that the back streets were a labyrinth of dark lanes)

Find Richard Whately's *Elements of Rhetoric* (1828, quoted here from p. 28 of the 1861 edition) contains a nice example of ellipsis within parallel structures:

"... it is understood that correct use is not founded on Grammar, but Grammar on correct use." (understood to mean that grammar is founded on correct use)

ENDINGS IN -WARD or -WARDS (TOWARD[S])

The preposition toward(s) and the adjectives / adverbs backward(s), downward(s), forward(s), homeward(s), inwards, onward(s), outward(s) and upward(s) present a choice whether to use the -s ending or not.

Backwards is far more common than backward as an adverb.

The adverb *forward* is far more common than *forwards*. The fixed expression *going forward* (meaning 'from here on') is extremely common in business English and in journalistic style.

Towards is more common than toward in British usage, though both are acceptable. American English writing tends to prefer toward, though speaking is more equally balanced.

She turned toward(s) the crowd and spoke.

With downwards, inwards, onwards, outwards and upwards, with the -s ending being more common in British English:

We found a footpath leading on downward(s), away from the peak.

They continued onward(s) until they saw some cottages.

In the case of *homeward(s)*, the two forms are more equally distributed.

When they function as adjectives, the -s ending is not used:

There was a *downward* trend in exports last year. *Inward* investment also suffered.

My homeward journey was far less stressful than the outward one.

ESPECIALLY and SPECIALLY

Especially means 'particularly' or 'above all'.

New England is wonderful, especially in the autumn.

Specially is used when referring to a specific or unique purpose of something.

The company makes office chairs *specially* designed for those who suffer from back problems.

The confusion may come from the fact that, in informal speaking, *especially* often sounds like *specially*. The difference is more apparent in writing.

EVERY DAY and EVERYDAY

As two words, every day is an adverb or noun phrase.

That sort of thing happens every day. (adverb phrase)

Every day seems to get harder and harder. (noun phrase)

Everyday is an adjective.

Everyday language is quite different from the formal language of legal texts.

EXCLAMATION MARK (!)

Exclamation marks are used after words and phrases that express immediate strong emotional reactions. The American English term is *exclamation point*.

Wow! Well, blow me down with a feather! I never thought I'd see you at the gym.

They are also used after what grammarians call exclamatives. These are typically clauses that look like questions but they aren't really; they're just strong statements.

Have I got news for you!

My God, did she make a fool of herself last night!

Exclamatives can also be constructed with what:

Thank you! What a kind person you are!

A traditional way of exclaiming using *how* has been overtaken by a different form in recent years. Instead of what was most common, i.e. a straightforward statement structure:

How annoying it is when people drop litter on the beach!

Nowadays, exclamations with *how* are frequently formed like a question:

He wants to go and live in a tree. How crazy is that!

There's also a tendency to use exclamation marks everywhere just to impress people that what you've got to say is newsworthy or very important, or perhaps more friendly and less like a set of instructions. I'd strongly advise against it! It really gets on people's nerves!

Some typefaces will allow you to produce a symbol which goes by the wonderful name of *interrobang*, a combination of question mark and exclamation mark (?), designed to express the questioning and exclaiming functions simultaneously.

FARTHER / -EST or FURTHER / -EST

When referring to distance, either one is possible.

How much further / farther is it to the hostel?

The farthest / furthest she ever travelled from her village was a day trip to the seaside. But that's how it was in those days.

When referring to more abstract meanings, *further* is the one to use.

Further discussions will be held before a final decision is made.

Further to my email of 3rd March, I can now confirm that we can come to fit the bathroom on Monday 16th.

Overall, further and furthest are far more frequently used than farther and farthest, so the 'u' forms are a safe choice.

FIRST(LY), SECOND(LY)

First and firstly can both be used to introduce a sequence of points or topics. Writers and (formal) speakers often use first, even when they follow it by secondly, thirdly, etc. Firstly, secondly, thirdly have a more formal ring to them than first, second, third. Lastly is generally preferred to last.

First(Iy), let me thank you for your kind donation; it was most generous of you. Secondly, I wondered if you would be prepared to talk to our group about your own experience in the field?

[intervening text] Lastly, may I ask you to complete the attached charitable Gift Aid form, which ...

When referring to a sequence of events in time, *first* is preferred to *firstly*.

'Aedile: List to your tribunes. Audience: peace, I say!

Coriolanus: First, hear me speak.'

(Shakespeare: Coriolanus Act III, Scene 3)

In speech, we often list different points using A, B and C:

Two reasons why I'm not going, A I'm a bit short of cash and B I don't like coach trips anyway.

People will tolerate up to C, but don't drone on to F, G and H; by that time, their concentration will have wandered.

FULL STOP or PERIOD

The full stop, or *period* as it's called in American English, is used to mark the end of sentences. It is also used to show that a word has been shortened by omitting letters up to and including the last letter of the word:

Prof. Carter will see you at 2.30pm. (Professor)

Phelan and Co. – your local estate agent (Company)

This book is by P. G. Wodehouse. (Pelham Grenville)

When the last letter of the word is retained, a full stop is not needed; however, American English generally prefers one.

Dr Wilson is on holiday this week. (Doctor) (British)

Mr. Hammond was a very kind man. (Mister) (American)

St Andrew's Church is about to celebrate its 800th anniversary. (Saint)

Some sets of initials, especially longer ones, look better without full stops. When writing someone's academic qualifications after their name, full stops are often not used:

Chairperson: Ellen Grimshaw MA, PhD

Dr Zenab Allewar FRSA will give this year's guest lecture. (Fellow of the Royal Society of Arts)

A full stop is sometimes used for effect when strictly speaking it doesn't mark the end of a sentence. This is common in advertising, evoking a friendly, conversational style of address to the unwitting victim.

We have some fabulous reductions for this week only. Which is why you should visit our website right away.

FRONTED ADVERBIALS

See ADVERBIALS

Gg

GAOL and JAIL

This is purely a spelling issue. Both spellings have a very long history but it looks as if *jail* has won the hearts of the people. *Gaol* has shown a sharp decline in use since the 1940s in British English, while *jail* has been the preferred spelling in American English for centuries.

Gaol versus jail in British English Source: Google Books Ngram Viewer http://books.google.com/ngrams

GERUND

See BASIC TERMINOLOGY: A GUIDE

GET

What you may have heard at school

When I was a kid, we sometimes had to do exercises where we had to substitute more elegant words instead of get. Overuse of get was considered a bit 'common' (i.e. lower-class, not 'common' in the sense I use it in this book, meaning 'very frequently used'). We struggled to say things like purchase a newspaper, obtain a job, grow dark, alight from the bus and so on instead of get, as these would have guaranteed to get us beaten up by kids from rival schools if we ever uttered them in the street.

The bad reputation of *get* persists, and there may be arguments for not overusing it in formal writing, but then that same argument would apply to overusing *vicissitude* or *jejune*; good style often depends on varying one's words. In everyday speech, we can get by fine using *get* as often we like. I've even got (gotten?) used to the now ubiquitous *Can I get a regular latte?* in cafés and coffee shops, where I still want to say *Can I have a regular latte?*

Past participle (got or gotten)

In general, got is considered a British English form and gotten is an American form. However, James Greenwood's The Royal English Grammar of 1737 gives both got and gotten as past participles of get. Later, Robert Lowth, Lord Bishop of Oxford and arbiter of grammatical correctness in the 18th century, rails against the use of got instead of the more desirable gotten as the past participle of get: This abuse has been long growing upon us, he lamented.

His A Short Introduction to English Grammar (1762) also has some nice, natural-sounding examples with get such as get me some paper, get to the end of, get the better of and get themselves a name. One of my early schoolteachers (not the one I thank in the acknowledgements in this book, I hasten to add) would have had him say bring me some paper, reach the end of, defeat and acquire a name for themselves.

So, *get* or *gotten*? Use whatever you've got(ten) used to but always think about the context and situation you're speaking or writing in.

See also DUNNO, GONNA, GOTTA, WANNA

The passive with get (she got fired)

The passive voice in sentences such as He was arrested for shoplifting and She was charged with manslaughter can also be rendered as He got arrested for shoplifting and She got charged with manslaughter. The get versions are more informal and much more common in speaking than in writing.

Interestingly, corpora of spoken English tend to show that the *get*-passive is more frequently used for bad news (people get arrested, fired, beaten up, locked out, thrown out; things get stolen, damaged, etc.) than for good news (get elected, awarded, promoted). Maybe that says more about our lives than about grammar. My late colleague Ronald Carter and I published a research paper on the subject.³

³ Carter, R. & McCarthy, M. (1999) The English *get* passive in spoken discourse: description and implications for an interpersonal grammar. *English Language and Linguistics*, 3 (1): 41–58.

Get-passive is more frequently used for bad news.

Go in speech reports (he goes, 'where are you?')

Go can be used informally instead of say in reports of what someone said. It is often used in the 'historic present' tense (i.e. the present tense used to dramatize past events). This use of go is extremely informal.

He looks at me and he goes, 'I know you from somewhere.'

The use of go to report speech dates back at least to Charles Dickens' time (though he uses the past tense, went); it occurs in The Pickwick Papers (1836–7), chapter IX, reporting the shouts of post-boys on a coach. Elsewhere in The Pickwick Papers, Dickens uses went to report the noise of gunshots (chapter XIX) and the rap of a door-knocker (chapter XXXVI), so we can see why go emerged as an apt verb for reporting speech and other sounds.

See also LIKE

GRAMMAR

Think of grammar as a set of conventions that evolve over time. As in any kind of natural selection, the most viable forms adapt to their environment and survive, new forms evolve and some forms become as dead as the dodo. Grammar changes to adapt itself to the environment in which it operates, just like Darwin's finches.

Don't think of grammar as a set of rules like legal statutes or the rules of chess. There are no grammar police (well, apart from teachers, examiners, the occasional pompous politician or journalist, bloggers and letters-to-the-editor writers). Grammar didn't come down from the skies and nobody came across it carved on tablets of stone. Grammar is a set of collective agreements about how we communicate. And the collective agreements change over time.

As with all social conventions, people judge one another on whether they adhere to them. Show up to a beach party in a formal business suit and people may think you're odd. Go for an interview for a job in a city bank dressed in a swimming costume, flippers and snorkel, and you probably won't get the job. Be careless with your grammar in personal profile statements, job applications or professional correspondence and you'll probably be judged in some way.

GUY(S)

For most British people, the word *guy* has a longstanding association with the historical figure of Guy Fawkes, who was foiled in an attempt to blow up the Parliament building and assassinate the king in 1605, an event still celebrated every year with fireworks and the burning of an effigy of Guy Fawkes on November 5th.

American English has for a couple of hundred years been using the word guy to mean a man, and in British English you will often hear people saying he's a strange guy or Jim and his brother are friendly guys.

The plural guys has found another use too in recent years, as a gender-neutral way of addressing mixed-sex groups of people:

Okay, guys, let's get started.

D'you guys want a coffee or something?

Weapon. Controversy raged in 2021 in the UK press over whether schoolteachers should stop saying things like 'Good morning, boys and girls' to their pupils since it stressed gender differences and reinforced gender stereotypes. Some preferred saying 'Good morning, everyone'. Others thought 'Good morning, guys' would do. Others protested that guys meant 'men'. Some thought it silly to ban the use of 'boys and girls', and there was a great lack of general agreement and strongly held views posted on the internet. (https://www.thesun.co.uk/news/14801924/primary-school-head-bans-sexist-phrases-birmingham/)

Hh

H- IN WORDS LIKE HISTORIC and HOTEL

I'm often asked which is better: a historic moment or an historic moment, and whether the 'h' is pronounced when people write an historic moment or an hotel. The pronunciation 'otel now sounds outdated, as does 'istoric. So, you can always safely say a historic event at a hotel near Hampstead Heath and sound every h-, but take a deep breath before you do.

Recently, a historian (or should that be *an historian?*) on a UK BBC TV documentary referred to late Medieval England as being a society where the common people looked up to *an hereditary nobility* (with the *h*- sounded), and a commentator on BBC Radio 4 news similarly pronounced *an historic gap* with a sounded *h*-. Both came over as strangely quaint and old-fashioned.

HAD BETTER

Had better refers to desirable or preferred courses of action.

I'd better text Anthony to see if he's coming today.

The government had better take more notice of its backbenchers.

In informal speaking and in some dialects, the *had* is often dropped:

You better make sure you get there on time. (informal / non-standard)

We better not stop here. It says 'No parking in front of these gates'.

HARDLY and HARD

In former times, *hardly* was used to mean 'in a hard or violent way'. In Mary Shelley's *Frankenstein* (1818), we find *My pulse beat so quickly and hardly...* Nowadays it means 'only just' or 'barely / scarcely'.

I *hardly* see my cousins at all these days except at weddings and funerals.

Hard is used instead to refer to difficult or violent actions and events.

His eyesight is deteriorating. He finds it *hard* to drive at night these days.

She hit it so hard it smashed into pieces.

Hardly already has a negative meaning; the thing to avoid in more formal contexts is slipping in a superfluous *not*:

His voice was so quiet we *couldn't hardly* hear him. (standard form: we **could** hardly hear him)

HAS YET TO and IS YET TO

Both these sentences are perfectly correct:

The exact process has yet to be decided.

The exact process is yet to be decided.

However, have yet to is many times more commonly used than be yet to. One or two expressions with be yet to are common enough (is yet to be seen, is yet to come), but the version with have is the preferred one in most cases.

HEADERS and TAILS (MY SON, JAMES, HE'S A PILOT)

Headers and tails are the names my co-author Ronald Carter and I gave to two common phenomena in spoken English in our *Cambridge Grammar of English* (2006). Here are examples of those phenomena.

Margaret, her husband, he's just got a job in Bristol, so they're moving.

Her car, that new [brand name], the back of it looks like a racing car.

He's a very good actor, Paul.

Oh yes, she's clever is Jenny.

We called the first two 'headers', since they are like headlines or like headers on an email telling you who or what the message is about. The second two are tails, because the identities of *he* and *she* are only given at the tail-end of the message. Tails are often used when giving a judgement or opinion about someone or something. Both of these forms are very common in everyday spoken grammar and are perfectly correct, but you would probably not want to write them, especially in a formal situation.

HE / SHE, HE OR SHE, THEY (EVERY CITIZEN SHOULD DO THEIR DUTY)

This is a dilemma that presents itself particularly with words like someone / somebody, anyone / anybody, no-one / nobody, each and every.

It was all very simple in olden times because every person knew his station in life and he never complained. Examples like that last sentence and these below are now considered outdated and sexist: Every citizen should pay his taxes on time.

Anyone who becomes aware that *he* is innocently in possession of stolen goods should contact *his* local police force immediately.

The debate has been over suitable replacements. Several candidates have put themselves forward and you can choose what sounds most natural, least awkward, most aligned to your politics, etc.

If anyone doesn't have sufficient support within the party, *he or she* will be unlikely to go forward to the next round of the election. (in speech is often heard as *he or she*, *he-she* or *he-stroke-she*)

If anyone doesn't have sufficient support within the party, he / she will be unlikely to go forward to the next round of the election. (in speech is often heard as he-she, he or she, or he-stroke-she)

If anyone doesn't have sufficient support within the party, (s)he will be unlikely to go forward to the next round of the election. (only applies to writing - tricky to say)

If anyone doesn't have sufficient support within the party, *she* will be unlikely to go forward to the next round of the election. (a way of fighting back after years of imbalance but no more genderneutral than *he*)

If anyone doesn't have sufficient support within the party, *they* will be unlikely to go forward to the next round of the election. (the easiest, most neutral and current favourite)

See also THEY / THEM / THEIR / THEIRS: SINGULAR AND GENDER-NEUTRAL; ZE AND HIR

HOWEVER

People often use a comma when two main (independent) clauses are connected by *however*. The traditional convention is to use a semicolon:

It was an interesting novel; however, I felt it was just too long.

HYPHENS

Hyphens: current usage

There are several places where hyphens were traditionally considered essential, but these are changing, especially in informal types of e-communication.

Hyphens: compound adjectives before nouns (a well-known composer)

Compare:

She's very *well known* in literary circles. (complement of verb *to be*)

He's a well-known composer of religious music. (compound adjective before a noun)

Their car had broken down. (phrasal verb)

A *broken-down* car was blocking the road. (compound adjective before a noun)

Other examples:

It was a hand-written invitation card.

They had some half-baked plan that was doomed to failure.

Some dictionaries give compound adjectives like *handwritten*, *homemade*, *deadpan* and *backdated* as one word with no hyphen and no space; others give them as hyphenated.

Hyphens: compound nouns (lamp-post or lamp post)

There is sometimes a choice between writing compound nouns as two words with a hyphen, as two words with a space, or as one word with no space. I have come across all of the following:

TWO WORDS	HYPHENATED	ONE WORD
lamp post	lamp-post	lamppost
book worm	book-worm	bookworm
home page	home-page	homepage
car park	car-park	carpark

Again, dictionaries vary as to how they represent such compounds and the general trend is towards losing the hyphen. Hyphenated forms of *today*, *tomorrow*, *weekend* and *email* (*to-day*, *to-morrow*, *week-end*, *e-mail*) now look dated. Most recently, *e-book* is often written as one word, *ebook*.

Where hyphens are still used (sister-in-law, self-catering)

Hyphens survive in compounds like *sister-in-law* and *son-in-law*. They are also used in expressions such as *vice-president*, *self-catering*, *a ten-year-old car* and in numbers written out (*sixty-six*, *twenty-four*). Some prefixes are still commonly used with a hyphen (e.g. *ex-wife*, *non-refundable*).

In formal writing, if two compounds share a common headword, they can be combined using hyphens to avoid repeating the shared element:

The movement brings together various *socially-* and *politically-oriented* philosophies. (i.e. socially-oriented and politically-oriented)

When not to use hyphens (we need to set up the room)

Don't use hyphens with phrasal verbs. Phrasal verbs are verbs that have two parts, a verb and an adverb particle (e.g. *take off, set up, stand by*):

We need to set up the room for the meeting.

British Airways flights usually take off from Terminal 5.

Stand by for some exciting news.

When the noun forms of phrasal verbs are used, single words or hyphenated forms may occur:

They put me on standby for the earliest flight the next day.

He did a brilliant take-off of Donald Trump.

See also PREFIXES AND HYPHENS

IF: STANDARD AND NON-STANDARD USES

Standard form (if I won the lottery ...)

Two common patterns of usage with *if* that often cause doubts, especially in more formal contexts, are the following:

If I move into town, I'll sell my car. (simple present tense verb in the if-clause + shall / will in the main clause)

If I won the lottery, I would give up my job. (simple past tense verb in the if-clause + would in the main clause)

This is the conventional, standard pattern.

Extra verbs added (if it hadn't have been for him, ...)

People sometimes use an extra would in the if-clause.

If we'd win the lottery, we'd never have to work again. (non-standard).

Unnecessary words seem to find their way into *if*-clauses like a virus. This is especially so when *if* is used to look back on past events.

If I would've known she was going to stay the night, I would've made up the spare bed. (non-standard)

If I'd known she was going to stay the night, I would've made up the spare bed. (standard)

The sentence only needs one *would*, not two. In conversation, probably nobody will notice if you use an extra *would* but in formal writing, you may want to think along more traditional lines.

Some speakers use an extra have. You will often hear sentences like:

If I had have known then what I know now, I would have trained to be a plumber. That's where the money is. (non-standard; standard: If I had known ...)

If it hadn't have been for him, I wouldn't have survived.

If I had known (or, more informally, If I'd known) and If it hadn't been are all you strictly need in these examples.

Find It's not only with *if* that the extra *have* is inserted. Conditional sentences without *if* attract it too. The unsuccessful Democratic Party candidate in the 2016 US presidential election campaign, Bernie Sanders, expressed his regret in a UK BBC radio interview that he would not be the official nominee, by saying:

I would have loved to have had the opportunity ...

The extra have could be taken out in two ways:

I would love to have had the opportunity ...

I would have loved to have the opportunity ...

If I was / if I were

Sentences with *if I were* ... use a subjunctive form of the verb *be* (*were* rather than *was*):

If I were to move to the States, I don't know where I'd prefer to live.

However, was has become more frequent in such sentences, especially in speaking, and especially in British English.

If I was to get a part-time job, I'd have more freedom.

In both American and British English, people prefer to say if I were you when giving advice.

If I were you, I would change my password.

INDIAN ENGLISH

The Oxford English Dictionary lists 1490 words which, whether recently or historically, have their origin in the languages of the Indian sub-continent, which is second only to the words the dictionary lists as originating in other European languages. British English culture, thanks to historical ties and a vibrant Indian immigrant and settled population, has been profoundly influenced by terms originating in the sub-continent, many in the realm of food and cooking. Many of these have become so absorbed into British usage that people no longer think of them as 'foreign' in any way. We don't have to go far into the alphabet before we find ashram, avatar, bhaji, bangle, chapatti, chutney, bungalow, catamaran, cummerbund, dekko, dinghy, Diwali, etc. All of these will be familiar in varying degrees to British and American English speakers and speakers of other varieties of English.

What is more, India can now lay claim to having the world's second largest population (after the USA) of English speakers, numbering over 100 million speakers. Indian English has become an independent variety of English in its own right. Where it differs from British or North American English does not mean it is wrong or inferior; it is just different.

One example of a difference in grammar is that scholars have observed verbs which can be used di-transitively (i.e. with two objects, as in *She gave me a present*) in Indian English which would not be used in that way in American or British English, where prepositions would be needed:

The company provided us samples of the material. (Indian)

The company provided us *with* samples of the material. (British / American)

They have not yet informed us the final date. (Indian)

They have not yet informed us of the final date. (British / American)

Fn The British Guardian newspaper's website in 2016 had a great headline: 'Don't prepone it – do the needful. 10 Indianisms we should all be using' (https://www.theguardian.com/commentisfree/2016/jan/04/indian-english-phrases-indianisms-english-americanisms-vocabulary). Prepone is a useful opposite to postpone. Prepone has existed with this meaning in American and British English for over a century but it is hardly ever used; instead American and British English speakers tend to say bring forward, or move to an earlier date. Although prepone has made it to the Oxford English Dictionary, the Merriam-Webster American English dictionary currently lists it as one of its 'Words We're Watching', i.e. words which have not yet met all the criteria for inclusion in the dictionary.

Other items in the *Guardian*'s list include *mugging* (to study hard), *do the needful* (do whatever it is I require of you or need from you) and *veg* (vegetarian). The gist of the article is that Indian English can provide us with useful expressions where other varieties of English have what linguists call 'lexical gaps' – gaps in the vocabulary where we have a meaning we want to express but no straightforward words are available to express it.

See also VARIETIES OF ENGLISH

INTERJECTIONS

See BASIC TERMINOLOGY: A GUIDE

IRISH ENGLISH

Irish English is an independent variety of English with some variations in grammar as compared with British English. For example, an Irish English speaker might say *He's after buying a new car*, where a British English speaker would say *He's bought a new car*. This form has its origins in the Irish Gaelic language.

Irish English speakers often use *so* at the end of a statement where British English would prefer *then*:

It's broken. I'll buy a new one so.

The traffic will be brutal. We'd better leave early so.

These differences are not indications of 'wrong' or 'bad English'. Irish English is an independent variety with its own roots and culture, just like North American or Indian or British or South African or any other variety or dialect of English.

IT'S or ITS

Here's something that for many people screams 'bad grammar!':

The team has lost it's way.

Standard form: The team has lost its way.

The reason for the confusion is that it's looks a bit like Clare's as in Clare's car, where the 's indicates possession.

It's is a short form of it is, i.e. a contraction like I'm, she's, he'd and they'll.

It's past midnight.

Its is a determiner ending in -s, like *his*. And while we're about it, remember that the pronouns *yours*, *hers*, *ours* and *theirs* don't have an apostrophe:

Are these gloves yours or hers?

See also YOU'RE AND YOUR

JARGON

Most professions, including my own, develop jargon – the words and phrases that are understood by the in-group and which act as a kind of shorthand for professional communication. Business and journalistic jargon are particularly common. Business people talk about blue-sky thinking and pushing the envelope, while journalists talk about breaking news and a read-across (connection, to you and me) between two apparently unrelated stories. In my own profession, I've heard management-speak referring to the digital pivot, their way of telling us we now have to do everything online which we used to do in classrooms.

There's nothing wrong with jargon except when people use it in a way that mystifies outsiders, and when they fail to consider who their audience is. A business commentator on BBC radio recently referred to 'some potential fallbacks of virtual on-boarding' (I kid you not). What she meant (I eventually worked out) was the negative sides of online versions of 'welcome to your new job / team'. Given that this was directed at a non-specialist audience, it was simply bad communication. People may use language in this way to try to sound knowledgeable or superior.

"Going forward, I'll keep you across some blue-sky thinking I've been doing about our vacation this year so we can diarize the best weeks and leverage the potential low-season offers."

Kk

KIND, SORT and TYPE

With these three nouns in the plural, people are often unsure whether to say:

There are different kinds / sorts / types of *headphone*: in-ear, on-ear and over-ear are the main ones.

or:

There are different kinds / sorts / types of *headphones*: in-ear, on-ear and over-ear are the main ones.

The second version (two plurals) was traditionally considered the correct one, but both forms are perfectly acceptable.

People are often uncertain as to the use of the singular form. Subtle differences in meaning are possible between singular and plural:

What *type of dog* is your favourite? (I'm thinking you'll choose one type)

What kinds of films do you prefer? (there may be several: thrillers, comedies, etc.)

What sort of music do you think we should have at your party? (we need to choose one sort)

What sorts of music do you like? (there may be several: rock, classical, jazz)

As always, be prepared to see all sorts of combination(s) of these patterns.

LEND

See BORROW

LESS and FEWER

The conventional rule is that *less* is for nouns we normally do not use in the plural. These are mass or uncountable nouns such as *equipment*, *flour*, *furniture*, *information*, *gas* or *petrol*, *progress*, *rice*.

This new heater uses a lot less energy than the old one.

Those cakes turned out okay but I think I'll use a bit *less sugar* next time.

Fewer is for nouns in the plural.

You see *fewer* and *fewer birds* on farmland these days. It's worrying.

Fewer people are wearing watches; they just use their phones to tell the time.

However, this is a rule that is observed more in the breach than the observance, and everywhere you're likely to hear and see *less people*, *less times*, *less emails* – in fact 'less' of just about everything. Supermarket express checkouts have been known to change their signs from *Five items or less* to *Five items or fewer*, probably after protests from purists.

And, as is so often the case, a glance back in time reveals evidence of usage which purists would abhor. Florence Nightingale, the founder of modern nursing, who trained nurses during the Crimean War in the 1850s, later in her life wrote in a letter dated 1899:

To the Aylesbury Dairy Co. Would you be so very good as to send me at once 6 eggs, if possible, laid this morning (or **less than 6** if not laid this morning) with the dark brown shells, for a gentleman very ill indeed, who fancies them ...

(reported in the London Times newspaper 11 April 2020)

LET'S

It's easy to forget the apostrophe when shortening *let us*: Let's stop now. I've had enough.

Most spell-checkers are good at picking that up.

Without the apostrophe, *lets* can be a present-tense verb or a plural noun:

He lets me borrow his bike when he's not using it.

Most of the cottages along the coast are holiday *lets*. (vacation rentals)

LIE or LAY

Lie, lay, lain

Lie is an irregular verb, i.e. its various parts don't follow the normal rule of adding -ed to make the past tense and past participle. Its different parts are lie (present), lying (present participle), lay (past), lain (past participle). It doesn't take an object.

When we go on holiday, we just lie on the beach all day.

Narwal was lying on the sofa, watching TV, when suddenly a thought struck her.

Yesterday I just lay in bed all day feeling wretched.

He'd lain unattended in a hospital corridor for six hours before help arrived.

Lay, laid, laid

Lay has these parts: lay (present), laying (present participle), laid (past), laid (past participle). It takes an object (underlined).

Lay your money on the table first. Then I'll give you the goods.

Our hens were *laying* about half a dozen eggs every day. We ended up giving eggs to friends.

The talks laid a solid foundation for the subsequent peace treaty.

The retreating army had laid roadside mines.

 F^n However, people often say things like this:

If you're not feeling well, go and lay down for an hour.

I'm looking forward to not working and just laying on the beach for two weeks.

And nobody bats an eyelid. Especially when they're lying on the beach with their eyes closed.

However, if you say *She just lied on the beach all day*, you're suggesting someone spent a whole day at the seaside telling untruths.

LIKE (IT WAS CRAZY, LIKE!)

People often complain that careless and lazy speakers (titles usually aimed at teenagers and other younger people) can't say

a sentence without every other word being *like*, including when introducing speech reports:

So, like he just like comes in and he's like, 'Who the hell are you?' and I'm like, 'Well, who the hell are you?' Like it was crazy!

These uses of *like* in informal speech are a badge of identity among friends and intimates. They are used by all age groups, though more by younger people: the British National Corpus shows that *like* occurs most frequently among the 18–30 age group. The use of *like* as in *It was crazy like* is hundreds of years old, but, as with any non-standard or highly informal grammar, there is a time and place for it and it may project entirely the wrong or undesired image of a person if used in inappropriate situations. Sometimes people use *like* to gain thinking time, or to fill what would otherwise be a silence.

See also GO IN SPEECH REPORTS

LIKELY

This is one of several grammatical grey squirrels; the American English version is becoming more and more common in British usage. This was the traditional distinction:

The election is likely to take place early next year. (British)

The election will likely take place early next year. (American)

In other words, British English treats *likely* as an adjective (compare *is certain to take place*). American English treats it as an adverb (compare *will certainly take place*). Both ways of using the word are venerably ancient.

LITERALLY

Literally means using a word or phrase in its absolutely precise and original meaning – well, at least that's what it means literally.

However, people use it frequently simply to emphasize what they are saying, or to give a signal that something sounds exaggerated or unlikely but is nonetheless true.

I was *literally* crying when I heard the news. (precise, original meaning)

He travels a lot in his job. He's been *literally* everywhere. (unlikely to be true, but emphasizing a great number of places)

LOAN

See BORROW

LOAN WORDS (KEBAB, MACHO)

English has been borrowing from other languages since time immemorial. It has an open and easy-going attitude to borrowing: if a loan word fits the bill and is felt to be usable to describe some new phenomenon, then in it comes. The only issue is whether we anglicize loan words in grammar and / or pronunciation.

French accounts for a huge number of borrowings, from *café* to *déjà-vu* (but you may have already sensed I was going to say that one). Overseas imperial adventures, trade and other types of contact between languages account for many other words such as *pyjamas* (Persian and Urdu), *catamaran* (Tamil), *cha* (tea: Cantonese), *alcohol* (Arabic). Music has brought us from Italian *alto*, *largo*, *soprano* and many other terms. Food is an ever-growing domain of loan words as the British become more adventurous in culinary experiences: *pizza* (Italian), *smorgasbord* (Swedish), *sushi* (Japan), *taco* (Mexican Spanish) are just a few that have entered the language in the last century.

Shakespeare loved including foreign words in his plays, often, as Norman Blake puts it in his book *Shakespeare's Non-standard* English: A Dictionary of His Informal Language, to emphasize the pomposity of the speaker (2006, p. 120). Foreign words in Shakespeare often come from Spanish and Italian.

Pronunciation and grammar are often anglicized over time, so we say *pizzas*, not *pizze*, *panini* and *paninis* instead of *panino* (singular) and *panini* (plural), and we talk about the *altos* and *sopranos* in a choir; these plurals would not be correct in Italian. Recently, the importation of the Spanish word *machismo* (used to describe an exaggerated and sexist male way of behaving) has caused some to anglicize the pronunciation to *mackismo*, while others retain the Spanish pronunciation, where the *-ch-* is as in *church*.

Even more recently, the Italian *latte*, used to describe coffee made with frothed milk, has had its main vowel lengthened by many English speakers (la-atte).

And it took me years to learn how to spell yogurt (yoghurt?).

In 2020, the coronavirus pandemic led to many countries going into lockdown, with restrictions on movement and social interaction. The noun *lock-down / lockdown* originally denoted a securing peg or pin for transporting timber, and is attested in the *Oxford English Dictionary* as an American term dating from at least the 1830s. The dictionary dates its use to refer to locking prisoners in cells to the 1970s and its wider use in public health and security situations to the 1980s. It is a great example of a transition from a physical object to a metaphor. The phrasal verb (*to lock down*) also dates from the 1970s. We are now all familiar with this piece of language and its role in our everyday lives, though most people would agree that it's better to be locked down than locked up.

LOOSE and LOSE

People sometimes confuse the spelling of these.

Loose is an adjective meaning not tight or firm.

That door handle is loose. One of the screws has come off.

We need a meeting to just tie up some loose ends.

Lose-lost-lost is the verb when you can't find something or have missed or reduced something.

Maybe we should cash our investments now. We don't want to lose any more money.

I've lost my keys again. Where can I have put them?

LOTS OF

Lots of is less formal than many of or a lot of.

Many of these problems go unnoticed for years. (more formal)

A lot of these problems go unnoticed for years. (less formal)

Lots of these problems go unnoticed for years. (least formal)

In written texts, *a lot of* is three times more common than *lots of*, in both British and American English.

See also A LOT

Mm

MADE OF, FROM, WITH, OUT OF

Made of usually describes the basic substance or material that composes something: a brooch made of pure gold, a worktop made of stainless steel.

Made from tends to be used for things created by re-using material in some way or mixing materials: a compost bin made from recycled plastic, whisky made from a blend of grains.

Made with is useful for talking about ingredients, especially in food preparation: pasta made with organic flour and free-range eggs, a dish made with butternut squash and coconut milk.

Made out of usually describes a process of changing the function of something: a picnic table made out of an old beer-crate, a doggie poop-scoop made out of an empty milk carton.

However, be prepared to hear any one of these forms used for any one of the meanings. What I've given here are the traditional differences.

MALAPROPISMS (ACRIMONIAL DEBATES)

Getting words not quite right can produce hilarious results. I recall almost falling out of bed with laughter a few years ago, when waking up to a morning radio news programme and hearing someone venting his rage about allegations of fraud that had been

made concerning trade-union elections. The interviewee said the allegations were serious and that the *alligators* should produce their evidence. *Allegator* and *alleger* existed centuries ago as noun forms of the verb to *allege* but have fallen out of usage, so we can forgive the speaker – the English lexicon failed him in his hour of need.

Shakespeare used malapropisms to great satirical and humorous effect. The character Bottom in *A Midsummer Night's Dream* (Act III, scene 1) refers to *the flowers of odious savours sweet* (odorous). Norman Blake's book on the Bard's use of non-standard forms lists numerous examples of purposefully exploited malapropisms.

Just recently, on a TV news programme, the newscaster (presumably reading off an autocue) quoted a public figure as having said that the return of selective grammar schools in England would be *socially diversive* (divisive).

Also recently, an academic, commenting in a BBC TV documentary on the amount of misogyny on the internet, said: *People feel they can say what they want with importunity* (impunity).

Others I have come across over the years include emergency heater (immersion heater), lesbian restaurant (Lebanese restaurant), bisexual hairdresser's (unisex hairdresser's), furniture with tubercular legs (tubular legs), youngsters from depraved backgrounds (deprived), aquifiers (aquifers), acrimonial debates (acrimonious), obeast (obese), no casual link (causal), deep-seeded problems (deep-seated) and a misspelt youth (misspent).

Most famous of all are some of ex-US President George W. Bush's efforts, my personal favourite being his assertion that people *misunderestimated* him. I'm never quite sure if that was a genuine quote or whether it is apocalyptic (sorry, apocryphal).

Tip: when in doubt, insult a good dictionary.

"I'm arresting you under the Malapropisms Act of 1984. I would devise you not to put up any existence!"

MALAYSIAN ENGLISH

See VARIETIES OF ENGLISH

MASS NOUN

See BASIC TERMINOLOGY: A GUIDE

MAY BE and MAYBE

May be as two words is a modal verb plus the main verb be. Modal verbs are verbs like can, could, must, might, would and so on. They express degrees of possibility or desirability.

It *may* be a good idea to have your passport with you. They might ask you for some ID.

Maybe written as one word is an adverb meaning that something is possible or could be true. It's an informal version of perhaps.

He's late. *Maybe* there's been a problem on the motorway or something, or *perhaps* he's just forgotten.

MEDIA

Media is the plural of medium, but it is often used as a singular noun referring to radio, TV and the press, or social media, as a collective idea.

The fax as a *medium* of communication is virtually obsolete. (singular noun)

News is now available in a variety of different *media*, not just through the press and broadcasting. (plural noun)

The *media* needs to be constantly on guard against state intervention. (singular noun: radio, TV and the press)

Social *media* often drives the news agenda these days. (the various online sharing media)

METER and METRE

A meter is an automatic measuring instrument, as in gas meter, speedometer, thermometer.

In British English, *metre* is the standard measurement of length in the metric system, as in 100 metres, five kilometres, eight centimetres.

American English uses the spelling *millimeter*, *centimeter*, *meter*, *kilometer*. I've had to stop my spell-checker from automatically changing them to the British spelling in order to show them here.

Some people say *KILometres*, others say *kiLOmetres*. Both pronunciations are in widespread usage.

MISPLACED PARTICIPLES (A HARE DRIVING HOME)

These are often a source of fun, but people usually understand what the intended meaning is in context. Here's an example. The participle clause (or *-ing* clause) is underlined:

I saw a hare driving home from Cambridge the other day.

There are easy solutions to make things unambiguous, such as moving the participle clause around and / or making the subject explicit:

When I was driving home from Cambridge the other day, I saw a hare.

"I saw a hare driving home from Cambridge the other day."

MISS (VERB)

This is not about *Ms*, *Miss and Mrs*. They're in the next entry. This is just to bring attention to an odd construction you hear quite a lot:

Since we moved into a flat, we miss not having a garden.

What they miss is *having a garden*. The *not* is superfluous. But people usually understand one another in context.

MISS, MS, MRS, MR, MASTER

Miss is definitely dropping out of usage nowadays, but one should respect the choice of any woman who prefers to be addressed as Miss, as opposed to the rather more neutral Ms, which doesn't reveal marital status.

Mrs is hanging on longer, but, again, it is a matter of choice and that choice should be in the hands of the person addressed. We shouldn't be dismissive of, or sneer at, people's choices in such matters.

What is definitely becoming less common is the following:

Mr and Mrs John Wilson invite George Lewoski to the wedding of their daughter, Grace, to Manfred Gries.

Presumably, wife and husband are not both called John.

Mr is still with us, but in recent years I've noticed how complete strangers from businesses I deal with treat me like a long-lost old pal and address me in emails as *Dear Michael*. My wife gets the same with her first name. I think we just have to live with that. If you complain, they usually send you an apology, address you as *Mr* or *Ms* and then spell your surname wrong.

Mrs, Ms and Mr are all followed by full stops / periods in American English (Mrs., Ms., Mr.).

When I was a little kid in the 1950s, I used to get birthday cards from aunts and uncles addressed to *Master Michael McCarthy*. People would probably only use that now in a jokey way.

MODAL VERB

See BASIC TERMINOLOGY: A GUIDE

Nn

NEVERTHELESS and NONETHELESS

These both mean 'despite what has gone before' or 'however'. *Nevertheless* is by far the more frequent of the two in both speaking and writing, and both words are less frequent overall in speaking than in writing.

Nonetheless can also be written as three separate words (none the less), but writing it as one word is twice as common.

NOUN

See BASIC TERMINOLOGY: A GUIDE

Oo

OFF

Off is a preposition or an adverb.

varnish dries.

They jumped off the bridge and swam in the river. (preposition) She ran off down the street. (adverb)

In American English and some dialects, people say of after off.

It was a belt with something like a purse hanging off of it.

Adam said we should stay off of the floor for a few hours while the

In standard British English, off doesn't need of after it; it's already a preposition.

OLDER, ELDER, OLDEST and ELDEST

Both the o-forms and the e-forms can refer to comparisons of two or more people's ages, but older and oldest are by far the more frequent and are used to refer to people and things. Elder is normally used about family relations and is most typically used before a noun, except in expressions such as the elder of the two / the elder of whom.

Who's older, you or your sister? (Not Who's elder?)

There were two brothers, the elder of whom, Archie, was killed in the war.

When the parents got divorced, her *elder / older* brother went to live with their father.

The eldest is often used without anything following:

They had three children: Rita, Fran and Kenneth. Rita was the eldest. (or Rita was the oldest)

For places and things, older and oldest are used:

We've always wanted to live in an *older* house, not one of these modern boxes with no garden.

St Andrews is the oldest university in Scotland.

The noun (*church*) *elder* is also used in religious contexts to mean a senior person in a position of leadership in a church community.

ONE IN THREE, ONE IN FOUR, ETC.

During a radio news broadcast on the BBC in June 2021, the announcer said:

One in four children in England qualifies for free school meals.

A matter of minutes later, a journalist commenting on the report said:

One in four children in England qualify for free school meals.

Which one was right?

It depends on how you look at the subject of the verb, whether you are considering each child as an individual who *qualifies* or as a group of children, the many thousands who *qualify* for the free meals.

ONES and ONE'S

Ones is a pronoun for referring to plural things instead of using or repeating a full noun.

I can only see my black shoes here. Where are my brown ones?

One's is a rather formal word. It's the possessive form of the pronoun *one*, which means 'me and anyone else who shares my world view'.

One hates to see one's best efforts come to nothing.

OUGHT TO

Ought to is a (semi-)modal verb which refers to things which should happen, ideally or morally speaking. Its use has been in steady decline over the last 100 years in British and American English, being replaced by should or need to.

I really ought to throw those old shoes away.

You *ought to* change your passwords regularly. (or *You need to / should change ...*)

Relative decline in the use of *ought to* in British and American English Source: Google Books Ngram Viewer http://books.google.com/ngrams

Questions and negatives with ought to are even rarer.

How ought we to proceed?

Behaviour like that ought not to be allowed.

Ought not follows the pattern for negating modal verbs (compare must not, should not, etc.). Some dialects treat ought more like a main verb and use didn't to form the negative:

Behaviour like that didn't ought to be allowed.

Some American English dialects allow *shouldn't* oughta, a doubling up of the modal meaning.

You shouldn't oughta smoke. It's bad for you.

As always with such non-standard dialect forms, awareness of appropriateness to the situation is important.

Vice-versa, in some dialects, an irregular past participle is sometimes used as the past tense.

I seen him yesterday. (standard: saw)

Ronnie done that; don't blame me! (standard: did)

I drunk too much last night. (standard: drank)

If you speak a dialect that uses such forms, don't be ashamed or feel you have to change. No dialect is inherently better than any other. The British Royal Family and posh politicians all use dialects; it's just that they use the established, powerful dialects of the upper-middle and upper classes which we no longer think of as dialects. The important thing is to be aware of dialect features and to use them in appropriate circumstances and to orientate towards the established standard when you feel it's more appropriate.

Past tense and past participle ending in -t or -ed (learnt or learned)

Some verbs have two possible past tenses, one ending in -t, the other in -ed. Common ones are burn (burnt or burned), dream (dreamt or dreamed), learn (learnt or learned), leap (leapt or leaped) and spell (spelt or spelled).

They've spelt / spelled my name wrong on this list.

By the age of 30, she had *learnt / learned* three foreign languages to a decent level of fluency.

I burnt / burned my finger on the frying pan.

Both endings are common in British English, while the -ed endings are preferred in American English.

PERIOD (.)

See FULL STOP OR PERIOD

PHRASAL VERB

See BASIC TERMINOLOGY: A GUIDE

PHRASE

See BASIC TERMINOLOGY: A GUIDE

PREFIXES (UN-, IN-, DIS-)

Prefixes: use and examples

Prefixes are added to the beginning of words to change the meaning in various ways, for example to create the opposite meaning (*unreal*, *impossible*) or to indicate a time (*preschool*, *midweek*). They don't normally have hyphens, with some exceptions (see Prefixes and hyphens). Some examples with adjectives and their opposites:

ADJECTIVE	PREFIXED ADJECTIVE	
possible, polite	impossible, impolite	
legible, legal, logical	illegible, illegal, illogical	
regular, responsible	irregular, irresponsible	
respectful, loyal	disrespectful, disloyal	
able, known, suitable	unable, unknown, unsuitable	
capable, active	incapable, inactive	

Although there are patterns here, they're not always an infallible guide: plausible becomes implausible, but pleasant becomes unpleasant. Invaluable is not the opposite of valuable. Use a good dictionary if in doubt.

Pp

PAST and PASSED

Past is a noun, adjective or adverb.

They just want to forget the past and look to the future. (noun)

They've learnt a lot from their past mistakes. (adjective)

I was crossing the road when a police car drove *past* at high speed. (adverb)

Passed is part of the verb to pass.

We passed by your house yesterday but your car wasn't there so we assumed you were out. (compare We drove past your house)

She passed him a piece of paper with an email address written on it.

PAST TENSE (TOOK) and PAST PARTICIPLE (TAKEN)

Forms and examples

English verbs are often listed in terms of their several parts, typically the three main ones of base form, past tense and past participle. Examples:

BASE FORM	PAST TENSE	PAST PARTICIPLE
live	lived	lived
arrive	arrived	arrived
take	took	taken
fall	fell	fallen
see	saw	seen
sit	sat	sat
put	put	put

Live and arrive are regular verbs: they just add -ed for past tense and past participle. The others are irregular, sometimes with a shared irregular past and past participle (e.g. sit, sat, sat), sometimes with two different forms (e.g. took, taken, fell, fallen), while for put, all three parts are the same.

The past participle is used with *have* (for present and past perfect) and *be* or *get* (for the passive voice):

We've lived here for 30 years. (present perfect)

Margaret had fallen asleep on the sofa and didn't hear the doorbell. (past perfect)

She was / got charged under the Prevention of Terrorism Act. (passive voice)

In some regional dialects, an irregular past tense is used as the past participle:

I haven't *took* the dog for a walk yet; I'll clean the floor when I get back. (standard form: *taken*)

We've never wrote a letter complaining about anything before now, have we? (standard form: written)

In 1751, the grammarian James Harris in his grammar, *Hermes*, refers to 'a corruption, at present so prevalent' of using the past instead of the past participle in utterances such as *it was wrote* and *he was drove*. So, there is little that is new.

Prefixes: variant forms (unfeasible, infeasible)

Sometimes, there are variants: both *unfeasible* and *infeasible* are found as opposites of *feasible*; *unfeasible* is the more frequently used. You can *unfriend* or *defriend* someone on social media; *unfriend* seems to have won that battle. *Untransferable* exists, but *non-transferable* is half a dozen times more common. *Non-negotiable* is many times more used than its neglected but equally correct sidekick, *unnegotiable*. Someone used *untransparent* on the radio recently, but *non-transparent* is far more frequent.

In 2016, media commentators just couldn't seem to agree on whether there were at that time moves to *unendorse*, *de-endorse* or *disendorse* Donald Trump as a US presidential candidate. All three popped up in one place or another.

As with all other aspects of the language, prefixes change over time.

Here are some examples of historical fights for dominance.

Unelegant is attested as the opposite of elegant in the 16th century but seems to have been overtaken by inelegant by the end of the 18th century. Another example is untractable (in use from the 16th century till the first part of the 19th), overtaken since then by intractable. Similarly, unpolite and impolite co-existed for a long while; impolite emerged as dominant by the mid-18th century.

When I was a kid, any material or substance that caught fire easily was called *inflammable*. By some obscure decree of the powers that be, this lost its prefix and became *flammable*. But not so fast with the indignation: *flammable* was in use 100 years ago, and the *Merriam-Webster Dictionary* informs us that it was a concern in the USA in the early part of the 20th century that people might think *inflammable* meant 'cannot catch fire', which led to firefighters officially recommending the adoption of *flammable*.

Source: Google Books Ngram Viewer http://books.google.com/ngrams

Prefixes and hyphens (pre-1980, prewar)

Prefixes are sometimes used with hyphens, but not always. These are some prefixes that can vary as to whether they attract hyphens:

HYPHEN	NO HYPHEN
anti-war	antimatter
post-medieval	postnatal
pre-1980	prewar
sub-standard	subsurface
non-flammable	nonnative
mid-century	midsummer

Prefixed adjectives: no non-prefixed equivalents (disgruntled)

You can be disgruntled but not gruntled, though P. G. Wodehouse wrote humorously of one of his characters: '... if not actually disgruntled, he was far from being gruntled.' You can be implacable but placable, though it exists, is extremely rare (my spell-checker is blowing a gasket over it). If you're dishevelled and

tidy yourself up, are you shevelled? [Note to spell-checker: stop changing that to shovelled.] Shevelled seems to have had a short and relatively undistinguished career then faded into oblivion. It actually wasn't the opposite of dishevelled but meant the same as dishevelled with the di- dropped, a case of aphaeresis (missing out the initial sound of a word). One that is often used for humorous effect is when people say they were underwhelmed by something (in contrast to overwhelmed). Whelm and overwhelm, with more or less the same meaning, have both been around for hundreds of years; underwhelm has been around since at least 1949, according to the Merriam-Webster Dictionary.

See also CREATIVE WORD-FORMATION

PREPOSITIONS (TO, FROM, OF)

Prepositions and object pronouns (to me, from us)

Prepositions are words like to, of, at, between, over, through, behind, on, in. It's worth remembering that they are followed by the object form of pronouns: me, him, her, them, us. It and you have the same form for the subject and object.

A common problem that arises is when the object of the preposition is a mixed one, as in this example:

Someone said there was a great *photo of Jamie and I* on Facebook today.

This should be *Jamie and me*, since both individuals are governed by the preposition *of*. Lurking here may also be subconscious memories of schooldays and being told that overuse of *me* was impolite.

See also SUBJECTS AND OBJECTS, BETWEEN YOU AND ME

Prepositions: ending sentences with

Fn

Fowler in his A Dictionary of Modern English Usage (1926) on more than one occasion dismisses as a 'superstition' the idea that prepositions should not be used at the end of a sentence. But the old myth persists to a surprising extent. It comes from well-meaning grammarians who thought English should be subject to the same rules as Latin, since Latin was the language of classical thought and culture and it didn't allow so-called 'stranded' prepositions. The following sentences are all perfectly correct.

I can't find any knives or forks. What are we expected to eat with?

There are all sorts of irrational things that rational people are afraid of.

Which box shall I put these books in?

James Greenwood's The Royal English Grammar (1737), dedicated to the then HRH The Princess of Wales, cited sentences such as Whom do you give that to? and He is the person I gave it to as examples of the preposition being put out of its natural place, but he seemed to accept it as being in common use. Another 18th-century grammarian who pondered where prepositions ought to be placed and ought not to was the Lord Bishop of Oxford, Robert Lowth. He wanted prepositions to be used in ways that suited the solemn and elevated style but admitted that stranded prepositions prevailed in conversation. (His A Short Introduction to English Grammar was published in 1762. The 1799 edition cost three shillings in old British money.)

Stranded prepositions

PRINCIPAL and PRINCIPLE

Principal as an adjective means 'main or most important'.

Her principal source of income is writing educational textbooks.

As a noun, it means the head of a school or college.

The *Principal*, Mr Robert Townsend, welcomed parents to the open day.

Principle is a noun; it means a basic idea or rule, or a moral standard or set of moral standards.

I agree with the plan in *principle*, but we need to discuss a lot more of the details before we go ahead.

It is against his *principles* to avoid paying tax, even though it may not be illegal.

PRONOUNS (I, ME, WE, US, THEY, THEM)

Subject and object pronouns (I, we, me, us)

Subject pronouns are words like I, he, she, we, they.

Object pronouns are words like me, him, her, us, them.

Here's a formally correct sentence:

George and I are going away next week.

And here's one that a lot of people would say but which is non-standard:

George and me are going away next week.

The two people going away form the subject of the verb, so the subject form *I* is considered correct, not the object form *me*. If George was not going away with you, you would just say *I'm* going away next week.

Using *me* as the subject often happens when it comes before another subject, especially in informal conversation.

Me and my cousin were born on the same day.

I and my cousin would sound too ponderous. My cousin and I would be okay.

So many things in informal conversation pass by entirely unnoticed. Just be careful in more formal situations.

Object pronouns (let Margaret and me know)

Here's a sentence (thinly disguised) from a business email I received recently.

Do let Margaret and I know how you wish to proceed.

Standard form: Do let Margaret and me know how you wish to proceed.

If Margaret wasn't involved, you wouldn't say Do let I know how you wish to proceed. You'd say Do let me know. Me is the object of let.

If you add Margaret to the sentence, you and Margaret together form the object, so you need an object pronoun, me.

Object pronouns (it was me / him / etc. that did it)

After it + be in cleft sentences with a *who*- or *that*-clause, we use the object pronouns except in very formal situations.

Get in touch with Mick Tyman; it was him that did all the plumbing.

It was me that was waving to you from the bus the other day.

Using the subject pronouns sounds very formal.

He is the one who organized the event.

It is I who should apologize, and I do that now, most sincerely.

Please address your comments to Mr Finn. It was he who

organized the event.

A way around this is to say: I am the one who should apologize /

Pronouns: object and possessive forms before -ing (do you mind me / my asking?)

In very formal styles, sentences like the following have the possessive form (my, your, our, etc.) of the personal pronouns:

Would you have any objection to my paying him a visit while he's in hospital?

They told me about your needing to consult a lawyer.

In less formal contexts it is perfectly acceptable to use the object forms of the pronouns:

Would you mind *me* paying him a visit while he's in hospital? They told me about *you* needing to consult a lawyer.

Pronouns ending in -one and -body (anyone, somebody)

The following alternatives are equally valid:

someone / somebody anyone / anybody no-one / nobody everyone / everybody

The main difference is that the forms ending in -body are more common in speech. The forms ending in -one have a slightly more formal feel and are more frequent in writing.

Fn A query spotted recently on the internet read: Is it better to be a real nobody than a fake somebody? When used as full nouns in this way, meaning a person no-one has heard of (a nobody) and its opposite, a celebrity of some sort (a somebody), the -body ending is normally used.

PROVIDED and PROVIDING (THAT)

Both forms are standard and both are more common in writing than in speaking. *That* is often omitted:

You can build without planning permission, *provided (that)* the extension does not exceed a certain percentage of the existing building.

Providing you're prepared to put in the time, being on the committee can be very rewarding.

As long as and so long as can be used with the same meaning and sound slightly less formal.

See also AS LONG AS AND SO LONG AS

PUNCTUATION

Punctuation is one of the ways we clarify meaning when writing. Think of it a bit like taking breaths between words and phrases when you speak, or the way your voice goes up or down when, for example, you want to ask a question, or the way you mimic someone's voice when you quote something they've said, or the way you want to express a strong reaction with words like wow, heavens or oh no.

A full stop / period is like a long breath or pause between two major chunks of speech; a semicolon, like the one I've just used, is a less definite break between the two chunks, and the commas in this sentence represent shorter chunks or breaks. Dashes before and after phrases are like taking a breath before and after to separate the phrase from the rest of what you're saying.

That's a simplified way of looking at punctuation. The individual entries for punctuation marks (see below) take things further and explain the standard conventions.

Nowadays, emailing, tweeting and text-messaging have led to a decrease in some kinds of punctuation but an increase in other symbols such as emojis to show the writer's feelings or reactions. When I was researching one of my recent books on grammar, I did an informal search of all the text messages I had received on my phone for the previous several months; there was not one semicolon anywhere to be seen.

A search on the internet will quickly yield reports that 'bad punctuation' in text messages can threaten your chances of landing a successful romantic relationship, so, be warned.

See also APOSTROPHES, COLON, COMMA, DASHES, EXCLAMATION MARK, FULL STOP, QUESTION MARK, QUOTATION MARKS / INVERTED COMMAS, SEMICOLON

Qq

QUESTION MARK

Direct questions (is she your teacher?)

Question marks (?) are used at the end of sentences with what linguists call interrogative clauses. Interrogative clauses involve words like do, did, have, had, can, must, should, will, is, are, was, etc., followed by a subject and a main verb. They are used to ask direct questions.

Are you coming with us?

Did she get that job she was after?

Why do people complain so much?

Wouldn't most of us prefer a later start? What do you think?

Since you're here, *could* you help us put out some tables and chairs?

The same applies after question tags (are they? will she? don't we? etc.).

We've been lucky with the weather lately, haven't we?

The boss likes her coffee black, does she?

The verbs to be and sometimes, more formally, to have can themselves be used as main verbs in interrogative clauses.

Are you an engineer, by any chance?

Has she any particular dietary requirement we should be aware of?

Statements heard as questions (you're not coming with us then?)

People often also use a question mark at the end of a statement which they want to be heard as a question. It can be quite useful in informal communications such as personal emails.

So you won't be with us next week if you're going away? I could email her right away if you like?

Indirect questions: no question mark (I asked her if she was okay.)

You don't need a question mark after an indirect question. Indirect questions are when someone reports the asking of a question. They are typically introduced by verbs such as ask, demand, wonder and enquire.

Direct question: Can we change our room?

Indirect question: We asked if / enquired whether we could change our room.

Direct question: Have you had time to look at that document I sent you?

Indirect question: I was wondering if you've had time to look at that document I sent you.

As usual, don't be surprised if you do see question marks used in indirect questions. Just remember that in formal situations, more traditional conventions may give a better impression.

Question marks in polite requests (would you pass me that book?)

We often use a question mark when making polite requests, even though, strictly speaking, they are not questions (in the sense of requiring a *yes* or *no* answer):

Could you let me know which days you would be available for a meeting next week?

However, we can sometimes avoid this dilemma by using a sentence with *if* ...

If you could let me know which days you would be available for a meeting next week, that would be most helpful.

Rhetorical questions

Rhetorical questions are questions that don't demand an answer from the reader or listener, and the questioner probably already has an answer in mind. They are often used just to raise a topic in the reader's or listener's mind. They end with a question mark.

The draft bill proposes changes to the regulations on food labelling. Why are the government doing this? It could be consumer pressure or there might be more sinister reasons.

QUOTATION MARKS / INVERTED COMMAS ('...')

It is customary to mark direct speech in some way, most typically by using either single or double inverted commas, often informally referred to as 66–99 ('...'). The reporting verb (say, ask, tell, reply, shout, etc.) is separated from the words spoken by a comma, which comes before the quotation mark. Final punctuation, such as a full stop, exclamation mark or question mark, comes before the closing quotation mark.

He asked, "What should we do now?"

"Leave town immediately," she replied.

Here I've used double quotation marks, but single ones are also common.

'What a dreadful mess!' she said as she walked into the room.

Fn A random (i.e. totally unscientific) sample of novels on my bookshelf shows a definite preference for single quotation marks, so a lot of printer's ink has been saved. A similar sample of academic books shows an occasional preference for a colon to introduce quotations from scholarly works.

In British English, short scholarly quotations and citations generally prefer the final quote mark to come before other punctuation marks:

Beirkov (1996) refers to such phenomena as 'non-evidential'.

American English punctuation often prefers the final quotation mark to come after a full stop / period:

Beirkov (1996) refers to such phenomena as 'non-evidential.'

See also COLON

Rr

RAISE, RISE and ARISE

This one is like lie or lay, or like quantum theory: you read about it, you think you've got it, then you go to bed, wake up the next morning and it's all fuzzy again.

Rise

Rise has these parts: rise (present), rising (present participle), rose (past), risen (past participle). It doesn't take an object.

Petrol prices *rise* when the oil price *rises* but they don't seem to go down when it falls.

Spring has arrived and the temperature is rising.

Shares rose on the London Stock Exchange yesterday.

Wages have risen by an average of 1.2% this year.

Raise

Raise has these parts: raise (present), raising (present participle), raised (past), raised (past participle). It takes an object (underlined).

I don't want to *raise* <u>your hopes</u> but I think there's a vacancy coming up soon in our office which would suit you.

They raised their prices during the recession. It was a mistake.

There is a complication. It concerns the nouns *rise* and *raise*. We normally talk about a pay rise or price rise.

I'd be afraid to ask my boss for a pay rise, but some people do.

However, on its own, *raise* is often used to mean an increase in wages or salary, especially in American English, which is probably influencing British English.

I'm due for a raise next year so I'll be earning more.

Arise

Arise (arising, arose, arisen) is similar to rise and is used for abstract contexts, where it means 'happen' or 'occur'.

A problem has *arisen* in connection with your order. Please contact us at this telephone number.

That's an example you'll be familiar with.

REFLEXIVE PRONOUNS (MYSELF, YOURSELF)

The singular reflexive pronouns are myself, yourself, herself, himself, oneself and itself. The plural ones are ourselves, yourselves and themselves.

We use reflexive pronouns when the subject and object are the same person or thing.

Sometimes I ask myself what on earth I'm doing in this job.

They protected themselves against possible encounters with bears by wearing bells around their ankles.

Reflexive pronouns can also be used for the full emphatical expressing of the person, as the grammarian James Greenwood put it in 1711. He cites thou thy Self, we our Selves and so on, written as separate words in his book (and with the capital letters as shown). This function of the reflexive is still in common use:

I myself would never ask such a big favour of a friend.

I know that you yourself have experienced similar problems.

Here's a use you'll see and hear when people are trying to be extra polite:

I'd like to invite Jane and *yourself* to join me for lunch at our London office.

You and Jane would be perfectly correct. This polite use of yourself is by no means new. James Harris, in his 1751 grammar, Hermes, dedicates the book to the Lord High Chancellor, with the words:

My Lord, As no-one has exercised the Powers of Speech with juster and more universal applause, than yourself; I have presumed to inscribe the following Treatise to your Lordship ... [punctuation as in the original]

It seems that people consider it correct and very polite to say things like the following, which a decidedly posh woman said on TV recently:

My friends and *myself* moved here for that reason. (standard form: *My friends and I*)

And here's one that you often hear which is a dialect form but which you'd probably want to avoid in writing and in more formal contexts.

They set theirselves a target of competing in the 2020 Olympics.

Occasionally, you will also hear theirself or themself. A poignant national appeal by the charity Samaritans a couple of decades ago reminded the reader that by the time they had read the text: someone will have tried to kill themself. It's clear why they put it this way, trying to avoid the plural themselves in order to urge the reader to focus on a real, individual person of either male or

female gender, even though it is non-standard. Here's another example, in this case suggesting a single, collective body:

It's an issue the Green Party has claimed for themself; they want it to be their issue.

The standard form is *themselves*, but be prepared to see and hear variations.

REGARD (REGARDING, WITH / IN REGARD TO, AS REGARDS)

This concerns the expressions regarding, with regard to, in regard to and as regards. All four are in widespread use, but regarding is the most frequent in both British and American written English. With regard to comes next. As regards and in regard to are less frequent in both varieties but as regards is more frequent in British English than in American English.

We received a letter from the county council *regarding* planning permission for our new garage.

I am writing with regard to your recent announcement concerning vacant seats on the committee.

A public fireworks display can be hellish expensive as regards insurance.

RELATIVE CLAUSES (THE GIRL WHO BROKE THE WINDOW)

Relative clauses (clauses that specify or add information introduced by *who*, *whose*, *whom*, *which* and *that*) can be a headache. There are basically three types.

Defining relative clauses (a van that was left unattended)

These are clauses that give essential information about a noun. In these examples, taking away the underlined clauses leaves us with very little information about who or what is being referred to, or with something that means something different.

Any person who causes wilful damage to the property will be prosecuted.

A van <u>that was left unattended near the airport entrance</u> led to the area being evacuated.

A woman whose bicycle was stolen five years ago was surprised to find it parked against the wall of her house.

Defining relative clauses are not separated off by commas.

Non-defining relative clauses (Waterford, which is Ireland's oldest city, ...)

These are sentences where the information in the relative clause is extra. We can leave it out without damaging the main message.

Waterford, which is Ireland's oldest city, was founded by Viking raiders.

Eric, to whom everyone looked for guidance, mounted the stage and began to speak.

Non-defining relative clauses are separated off by commas.

Sentential relative clauses or comment clauses (..., which is pretty cheap really)

These are *which*-clauses that comment on a whole clause or sentence. It cost \$28, which is pretty cheap really.

As the job got harder and harder, which it did, I began to have second thoughts.

Sentential relative clauses are separated off by commas.

See also WHO, WHICH, WHOM, WHOSE, THAT AND WHAT

RIGHT(LY), WRONG(LY)

These are cases where the basic, everyday adverb doesn't end in -ly.

They never spell my name right.

It all started to *go wrong* when Norman and Paula joined the committee.

H. M. Queen Elizabeth II, in 1975, when ceremonially turning on the flow of North Sea oil to Britain, said:

If we use it *right*, this flood of energy can, without doubt, much improve our economic wellbeing.

Rightly and wrongly are mostly used before past participles and have a meaning of 'justifiably' and 'unjustifiably':

She was rightly annoyed by what was said.

The men were wrongly accused of being involved in terrorist activity.

Tight(ly) is a bit different.

Tie it tight / tightly now; otherwise it'll all fall out. (You're likely to hear both.)

All the sheaves are then tightly bound with raffia string.

Hold tight, darling! We don't want you falling out of the boat.

Hold tight! is a fixed phrase. It always sounded mildly absurd and over the top to me whenever I rode on the driverless shuttle at one of Britain's leading airports and a recorded voice advised everyone to hold tightly! as the shuttle was about to leave.

See also HARDLY AND HARD

Ss

SEMICOLON

In 1995, a learned scholar published a paper that included in its title *The Rise and Fall of the Semicolon*.⁴ Apparently it was extremely popular in the 17th and 18th centuries. It seems to have set off on a downward trajectory since then.

The American satirical writer Kurt Vonnegut, in his 2005 collection of essays A Man Without a Country, discouraged the use of semicolons, referring to them as representing absolutely nothing.

If, like me, you'd be sad to see such a nice old friend disappear from the face of the earth, then here's what it's for. Use it or lose it.

A semicolon (;) separates two main clauses. It suggests a shorter pause for thought and a stronger connection between the two clauses than a full stop, but a more decisive break than using and.

At 70, you can renew a UK driving licence online and you don't have to take a new test.

At 70, you can renew a UK driving licence online; you don't have to take a new test.

At 70, you can renew a UK driving licence online. You don't have to take a new test.

⁴ Bruthiaux, P. (1995) The rise and fall of the semicolon: English punctuation theory and English teaching practice. *Applied Linguistics* 16 (1): 1–14.

All three are correct. It's your choice as to how strong you want the link to be.

Some writers use the semicolon to separate items in lists, especially where there are longer items, instead of using commas. Have a look at the list of people I've thanked in the acknowledgements at the end of this book, where I've used semicolons in this way.

See also HOWEVER

Decline in semicolon use: English fiction Source: Google Books Ngram Viewer http://books.google.com/ngrams

SENTENCE

See BASIC TERMINOLOGY: A GUIDE

SHALL and WILL

In my day, we were taught at school that *shall* was for first person subjects *I* and *we*, and *will* was for second (*you*) and third person (*he*, *she*, *it*, *they* and nouns).

I shall never forget the day my daughter was born.

They will arrive sometime next week; we shall be able to confirm the exact time in the next few days. However, this varies widely across English varieties and dialects, with many (including my own) preferring will for all persons:

We will have to apply for a visa but we can do it online.

American English generally prefers will. Shall is more than ten times as common in spoken British English than in American English.

Shall is still widely used to make suggestions or proposals, e.g. the fixed social formula Shall we dance?

Shall I get some more milk while I'm at the shop?

Irish and Scottish English often use will to make proposals and offers:

Will I put the kettle on and make a pot of tea?

As always, don't think your dialect is inferior. Just make the choice you think is most appropriate for the situation. In everyday speaking, *shall* and *will* both normally contract to '*ll* after a subject, so the difference is less important; it's in writing that the choice becomes more apparent.

SIGHT or SITE

People often get *sight* and *site* mixed up. *Sight* is to do with seeing, while *site* refers to locations.

I knew the doctor was supposed to be there somewhere but I didn't catch *sight* of her.

When we're at conferences in big cities, we don't often get a chance to get out and see the *sights*. (the things worth seeing)

The hilltop was the *site* of a Neolithic village. (a place where something existed or happened)

SINGAPORE ENGLISH

See VARIETIES OF ENGLISH

SO

Interviewees on radio and TV often use so to start a response to a question where the answer is not a logical conclusion to or a result of the question:

Interviewer: How do you propose to express your opposition to the new runway?

Interviewee: So, what we intend to do is to commission our own report ...

There's nothing wrong with this and the respondent might equally have begun the answer with *Well*. It may just be a tactic for getting a bit more thinking time. But it does irritate a lot of people, who complain to me because they know I am a linguist.

So is by no means always related to logical conclusions or results. It is often used to launch a conversation or a new topic:

So, how's life, Sonia?

SOME TIME or SOMETIME

Some time (two words) means a period of time.

It would be nice to spend some time together. When are you free?

Sometime (one word) means a time that is not specified.

We'll probably go to Florida *sometime* in the autumn when it's getting cold here.

Sometime is also used when referring to a position or job held by someone in the past but no longer.

Meera Singh, *sometime* theatre critic and radio celebrity, has decided to become an environmental campaigner.

You could also say *erstwhile theatre critic* instead of *sometime* in this last example.

SOMEWHAT

Somewhat is an adverb meaning 'to a degree'.

Life has become somewhat hectic recently.

The city has changed somewhat since it hosted the Olympic Games.

In British English, it is more than ten times more frequent in writing than in speech. It can sound rather formal. In American English, the gap between speaking and writing is far smaller.

SPEAKING and WRITING

The 18th-century grammarian, James Greenwood, in his *Royal English Grammar* of 1737, had his eye on the different knowledge required for speech and for writing:

For tho' it is possible that a Young Gentleman or Lady may be enabled to speak well upon some Subjects, and entertain a Visitor with Discourse agreeable enough; yet I do not well see how they should write any Thing with a tolerable Correctness unless they have some Taste of Grammar, or express themselves clearly, or deliver their Thoughts by Letter or otherwise, so as not to lay themselves open to the Censure of their Friends ...

Throughout this book there are references to things that are acceptable in everyday conversation but less so in contexts such as formal correspondence or situations such as formal meetings or job interviews. The grammar of speaking and the grammar of writing draw on the same resources but in different ways.

Everyday conversation happens in real time; it is created online, so to speak. All sorts of things that purists frown upon in writing go unnoticed in everyday speech and are often used by the very same purists themselves.

Any politician, journalist or Prince of the Blood Royal who rails against 'sloppy' usage such as *gonna* and *dunno* instead of *going to* and *don't know* should listen in to a live debate in the UK Parliament, where these forms are commonly heard – though they're usually 'tidied up' for the official record, as Rebecca Hughes's excellent 1996 book *English in Speech and Writing* demonstrates.

The most important thing is to be aware of the different demands grammar places on us in different situations. If you grew up speaking one of the many lovely world or regional dialects of English and then had it drained out of you through years of education or in the work environment, you may yet feel most comfortable slipping back into your dialect grammar and vocabulary when you go back to your original community or meet up with old friends. That's a far cry from writing a formal business report or email, or being on the receiving end of a crucial job interview, where you want to identify with a different community.

SPELLING: -OR and -OUR

Labor, color and flavor, spelt with -or in American English, are spelt with -our in British English: labour, colour, flavour. A couple of centuries ago, American English used the present-day British spellings more. In the 1830s, the situation changed and, as the graph shows, in a neat crossover, the current American spellings took over in American writing and the British spellings declined.

See also -CE OR -SE (PRACTICE, PRACTISE)

American English 1800-1850s

Source: Google Books Ngram Viewer http://books.google.com/ngrams

SPLIT INFINITIVES

A split infinitive is when something is placed between *to* and the verb it is attached to. Some people think this is 'bad grammar'. It isn't. Sentences like this one are common in spoken and written English:

It's a good idea to regularly change your passwords.

So, feel free to always split infinitives unless the inserted matter is so lengthy that to, at that point and without proper regard for your reader, a phenomenon often referred to as a lack of 'audience design', break up the sentence would make it impossibly difficult to read.

STATION

For most of my life, the place where you go to catch a train was called a *railway station*, but increasingly, *train station* is used.

The popular Netflix series *The Crown*, tracing the history of the reign of Queen Elizabeth II of the UK, contained an episode in which the Queen's aristocratic distant cousin, Lord Mountbatten, referred to taking control of the 'train stations' during the planning of a fictitious coup d'état in the 1960s – a usage that would have been quite alien to him.

Train station vs railway station: British English Source: Google Books Ngram Viewer http://books.google.com/ngrams

SUBJUNCTIVE (I INSIST THAT HE APOLOGIZE)

This is probably something you were tortured with at school when you studied French or Spanish (remember those awkward verb forms you had to use if you said *I want you to help me* or *I wanted him to join our club?*). You may have even been told that the subjunctive doesn't exist in English. It does.

In some ways, the English subjunctive is simple: the base form of the verb is always used (i.e. you don't need an -s ending on the present tense with *he*, *she*, *it* or a third person noun and you don't need to mark the plural or past tense), as in these examples:

I insist that *he apologize*; a bottle of wine through the post is not enough.

It was always considered important that *a male child be* taught hunting skills from an early age.

It is essential that they not be made to feel excluded.

As is apparent, these forms belong to rather formal writing and are rare in anything but the most formal speech. If you want to use them in formal situations, they tend to follow expressions of obligation or desirability, i.e. verbs like *insist*, *demand*, *require*, adjectives like *important*, *essential*, *imperative* and nouns such as *requirement*, *stipulation*, *insistence*, etc.

If you don't want to use them, just insert *should* before *apologize* and *be* in the first two examples and before *not* in the third one above, and it works perfectly well.

Some subjunctives in English are common phrases that we hardly think of as subjunctive:

Someone should take responsibility, whether it be the school or the parents.

Any branch of the arts, *be it* music, theatre, poetry, painting, is struggling financially nowadays.

Another form of subjunctive involves using *were* instead of *was*:

If I *were* you, I'd get a ticket now; they're selling fast.

If I was you is often heard but it is considered non-standard.

If there were to be an election tomorrow, the party would probably lose.

Were it to happen that she moved to a new address, she would probably have to apply all over again.

Generally, American English uses the subjunctive more than British English.

See also IF I WAS / IF I WERE

SUFFIXES (-FUL, -ITY)

Suffixes: use and examples

Suffixes are added to the ends of words, typically to change their word class and / or meaning, for example to change a noun into a verb or an adjective, or vice-versa. Some examples:

VERB	NOUN	ADJECTIVE
exploit	exploitation	exploit <i>ative</i>
brut <i>alize</i>	brutality	brut <i>al</i>
play	player	playful

Suffixes: -ic or -ical

Some adjectives have two forms, one in -ic, the other in -ical, with different meanings.

It's a very *economical* car – we only need to fill up every couple of weeks. (doesn't use a lot of energy, doesn't cost too much)

Economic policy seems to be decided by a series of knee-jerk reactions these days. (concerning the economy of the country)

Wordsworth's *classic* poem, 'I Wandered Lonely as a Cloud', is often mistakenly called 'Daffodils'. (of the highest quality, by which other poems are judged)

It was a *classic* case of the left hand not knowing what the right hand was doing. (a typical example of something annoying or funny) BBC Radio 3 plays not only *classical* music but jazz, folk, all sorts of things. (music of the long, formal tradition of past centuries) She's an expert in *classical* architecture. (architecture of ancient Greece and Rome)

The *historical* evidence of land ownership in the area shows the dominance of a handful of rich families. (related to history, the study of the past)

The signing of the Good Friday Agreement in Northern Ireland was a *historic* moment heralding the end of years of conflict. (of great importance in history)

English Heritage manages over 400 *historic* buildings, monuments and sites in England. (of great importance in history)

Suffixes: gendered / sexist terms (headmistress / waiter)

Until relatively recently, a lot of jobs were gender-marked with suffixes. Many now consider such usage as old-fashioned, inappropriate or sexist. In some cases, what used to be the male term is used for both sexes; in others, new versions have emerged. Here are just a few examples. It is generally considered good practice nowadays to use a neutral term.

MALE	FEMALE	NEUTRAL
tailor	tailoress	tailor
murderer	murderess	murderer
headmaster	headmistress	headteacher
policeman	policewoman*	police officer
waiter	waitress	waiter, server
spokesman	spokeswoman	spokesperson
fireman	firewoman	firefighter
chairman	chairwoman	chair, chair person
manager	manageress	manager

^{*}When I was a kid, we used to say lady policeman for this one.

Actor and actress are still both in use at the time of writing, but actor is steadily taking over for both sexes.

Air hostess now sounds terribly dated and cabin steward, cabin attendant or cabin crew member are fine for both sexes, as is flight attendant.

Dylan Thomas, in *Under Milk Wood*, got round the *fishermen* problem by referring to *fishers* but then immediately followed it with *tradesmen*. The same passage also includes *schoolteacher*, policeman and postman, so it's a mixed bag. But then Dylan Thomas was perhaps paying more attention to poetic metre, and things were different in the 1950s.

Suffixes: variants (individuality, individualism)

Sometimes two possible suffixes are available but with slightly different meanings or differences in style. A recent commentator on TV referred to the *fervency* of the beliefs of a religious group; *fervour* also exists, with more or less the same meaning, and is by a great margin the more frequent of the two. Another example is *secularity* versus *secularism*, where the alternating suffixes express a subtle difference in meaning. *Secularity* means the state or situation of living without being guided by religious principles, while *secularism* refers more to the doctrine or ideology that life should be based on non-religious principles. I have read both recently in the press.

An *arbiter* is a person who is considered the best judge or authority in a matter (e.g. a fashion magazine as *the arbiter of style*) and was, in the past, also a person appointed to sort out a dispute between two parties. This latter meaning has now been taken over by *arbitrator*.

Fn BBC radio recently featured an interview with a young man who was working as a bicycle-courier delivering fast food, who enjoyed certain aspects of his work but didn't like *the precarity that it puts us under. Precariousness* is by far the more frequent noun form, but *precarity* is more specific, referring especially to insecure and / or exploitative working conditions and other types of personal insecurity.

Other examples of variants include *individuality* versus *individualism*, *hallucinative* versus *hallucinatory*.

In questions of variants concerning suffixes, a good dictionary will help with such choices.

Suffixes: bits of 'tat' (preventive, preventative)

Sometimes an extra -tat-, -at or -ate syllable distinguishes variants in suffixed words. The online Collins English Dictionary gives both preventive and preventative as adjectives from prevent, but gives preventive as the main entry. On the other hand, the dictionary gives interpretative priority over interpretive in its headwords, albeit additionally giving a special computer-related meaning to interpretive. Orientate is given as a variant of the verb orient, rather than vice-versa, but both are in frequent use.

Meanwhile, to administer is the preferred form for giving medicines, oaths and sacraments. To administrate can be applied to the management and application of information and business:

Nowadays, software licensing has become less complex and easier for developers to *administrate*.

Suffixes: overloading (hallucinatorily)

Fn A TV historian recently referred to an ancient group of people as working *Herculeanly*. *Herculean efforts*, yes, but beware of tongue-twisters. In relation to the variants *hallucinative* versus *hallucinatory* mentioned above, there is the veritably tongue-strangling adverb form, *hallucinatorily*.

Changing suffixes (racialism / racism)

Back in the 1970s, people who disliked or looked down upon people of other races were called *racialists* and their attitude was referred to as *racialism*. The *-al* part of the suffix seems to have disappeared and nowadays we have *racists* and *racism*. This change seems to have started in the 1960s, since when the versions without *-al* have greatly increased in frequency, especially since the 1980s. However, the adjective *racial* persists in phrases such as *racial hatred* and *racial prejudice*.

Racialism vs racism: British and American English Source: Google Books Ngram Viewer http://books.google.com/ngrams Then there's a case where whole suffixes have almost vanished. Thanks to George W. Bush's War on Terror, the media have wholeheartedly abandoned the adjective terrorist (now mostly used as a noun referring to the person) and the noun terrorism. We now hear of anti-terror police (are they a special kind of police, or shouldn't all police be against terror?), anti-terror laws, terror attacks, terror outrages, events that are non-terrorrelated and so on. Back in 1981, the newspaper headline Terror in Southall referred to street riots in the London suburb involving gangs of youths. Nowadays, the same headline would immediately suggest a terrorist atrocity.

These two examples show that suffixes, as with any feature of language, can evolve and change over relatively short spans of time. The media plays a major role in the process.

SUPERLATIVE (BEST, MOST FRIGHTENING)

Superlatives are used to single out a person or thing as having an outstanding quality in some way compared with other members of their class.

The Finkel brothers are the best guitar duo I've ever heard.

What's the most frightening film you've ever seen?

In the case of superlative adverbs, the is often omitted:

Who reigned (the) longest, Elizabeth I, George III or Queen Victoria?

See also COMPARATIVES

TAUTOLOGY (A ROUND SPHERE)

This is not, strictly speaking, a grammatical or vocabulary issue but is more an issue of style. However, it comes up so frequently in conversation with friends who think I must be a world expert on it (or at it) that it deserves some space here.

Tautologies occur when an idea is needlessly expressed twice; 'needlessly' is the key word. Poets, playwrights, orators, advertisers, etc. often repeat things for a wide range of effects. Tautologies typically prompt the question: what else could it be?

A round sphere floating in the sky (what else could it be but round?)

A new *underwater submarine* can dive to greater depths than ever before. (One noted as odd by a BBC radio newsman, April 2021)

The tree was hollow inside.

It all happened around 10:00 am in the morning.

That was our end goal.

Fowler, in the monumental A Dictionary of Modern English Usage, cites time-scale (for time), behaviour pattern (for behaviour) and weather conditions (for weather) as tautologies. Condemning weather conditions is a bit unfair as the term normally applies to the conditions brought about by the weather (icy roads, poor visibility, etc.), but you can see what he is getting at. Other favourites that are often quoted are factual information

and *totally unique*; these last two have more or less become fixed expressions that go largely unnoticed, though I did hear *completely unique* on the radio the other day.

THAT OF

That of is used in comparisons instead of repeating a noun: Her salary is equivalent to *that of* a university lecturer. (i.e. equivalent to the salary of ...)

This can be expressed less formally with a possessive 's: Her salary is equivalent to a *university lecturer*'s.

In very informal talk, it is likely to go unnoticed if you say: Her salary is equivalent to a university lecturer.

However, a purist would object to the comparison between a salary and a lecturer, rather than a comparison of two salaries.

A salary equivalent to a university lecturer

That of is used after expressions such as the same as, similar to, different from / to, greater / less than, like and comparable to / with.

THE and TO: PRONUNCIATION

Recently there seems to have been a shift in the pronunciation in standard British English of *the* and *to* when they are followed by a word beginning with a vowel sound. Before a vowel sound, traditionally, *the* is pronounced 'thee' and *to* is pronounced in the same way as 'too':

the end (thee end), the office (thee office), to Edinburgh (too Edinburgh), quarter to eight (quarter too eight)

'Thee' and 'too' are called the strong forms of *the* and *to*. Now the trend is to use for everything what linguists call the weak forms ('tha' and 'ta' – pronounced like the 'a' in *ago*, what phoneticians call a schwa, the symbol for which is like an upside-down 'e' /ə/). And speakers now routinely produce a glottal stop after *the* and *to* before a vowel sound. A glottal stop is the sound that occurs in the parody of Cockney pronunciation of words like *water* (wa-er) and *daughter* (dau-er) or in the reactive expression *uh-oh!*. Here are some examples I've heard lately on UK radio and TV from speakers whose accent otherwise conforms to the standard:

It takes me an hour to get to tha office.

When we come to tha end of the process ...

The time is coming up to a quarter ta eight.

People are often too afraid ta ask.

These pronunciations have long existed in some dialects and varieties of English but they are now becoming mainstream in the UK. As always, choose what you feel is appropriate to the situation.

THERE IS and THERE ARE

This is one where speaking and formal writing differ greatly in what is acceptable.

Traditionally, *there is* takes a singular complement; *there are* takes a plural complement (complements are underlined).

There's a problem with the washing machine.

There are three restaurants in the square by the station.

However, *there's* with a plural complement is now heard so frequently in speaking that it has almost become standard usage, especially with expressions of number such as *lots of, a few, five, nine, loads of*:

There's quite a few empty boxes in the garage. Do we need to keep them?

In more formal situations, especially in formal writing, you may wish to stick to the traditional usage.

Some researchers have noted that varieties of English other than British or American are more conservative on the question of agreement with *there is* and *there are* (e.g. Nigerian English, Trinidadian English).

THERE, THERE'S, THEIR, THEIRS, THEY'RE

People often get these mixed up. *There* is either an adverb of place or an existential pronoun (i.e. it indicates the existence of something):

Put it over there on the table, please. (adverb of place)

There's a problem with this software. (existential pronoun)

Their and theirs indicate possession by more than one person or thing.

Border terriers are great dogs. *Their* coat is usually quite wiry.

I asked Jo and Felix about that bag I found in the hallway. They said it's not *theirs*. I wonder whose it is.

They're (meaning 'they are') often sounds like there or their in speech. In writing it is important to spell each one differently.

An article in the London *Times* newspaper (19 November 2019, p. 3) reported on a Dutch study of the impact of language errors in postings on online dating sites, and how spelling and grammatical errors resulted in the writer being perceived as less attractive. The English example the journalist Rhys Blakely gave as analogous to the Dutch ones was writing *their* instead of *they're*. Who would have thought the humble apostrophe could so determine one's love life?

THEY / THEM / THEIR / THEIRS: SINGULAR and GENDER-NEUTRAL

Purists object to the gender-neutral use of *they* used with words like *somebody*, *everyone*, *person*, etc., but it is perfectly correct to say:

Everyone has their own personal problems to deal with.

Somebody has left their phone in the meeting room. I wonder if they realize?

The pronouns *they / their / them / themselves* referring to a singular entity are not some modern horror perpetrated by the linguistically lazy. Their use is attested in the highly-respected *Oxford English Dictionary* as far back as the 15th century.

The celebrated 19th-century essayists Walter Bagehot and John Ruskin used the singular *they* a good century before anyone dreamt up the notion of linguistic political correctness. They / them is also useful when referring to someone who is still

unknown to you, and is less cumbersome than saying *he or she* or *him or her*. For example:

The new person is starting soon. We need to get the workspace ready for *them*.

More recently, people have felt freer to express a non-binary or transgender stance with regard to their identity, and *they / them*, etc. has come to the rescue again. A UK newspaper in 2021 introduced the new non-binary mayor of the Welsh town of Bangor as 'their worship' and referred to the moment the new mayor 'climbed to the stage to accept their position' and quoted the new mayor as saying that 'they felt "hugely humbled" to represent their community' (*The Observer*, 13 June 2021, p. 21).

See also ZE AND HIR

THOSE and THEM

A wonderful old dialect speaker in my village, now deceased, said to me:

She lives in *them houses* down at the bottom of the village, you know.

If this is a feature of your dialect, just remember that the standard form is *those houses* and choose appropriately, according to the situation.

TILL and UNTIL

As prepositions, these mean the same, but *until* is, overall, many times the more frequent. In speaking, the gap narrows considerably, with *until* winning only by a head.

An old-fashioned way of writing *till* as 'til has now dropped out of usage.

TIME, AND HOW WE TELL IT

How we tell the time changes as our technology and social habits change. When I was a child, older people said 'five-and-twenty to six' and 'five-and-twenty past nine'. Then everyone just said 'twenty-five to six' and 'twenty-five past nine'. Clock faces often had Roman numerals, but most people seemed to be able to read them without too much trouble because they were familiar with their position on the dial.

When the day was divided into two twelve-hour periods, it depended on whether you were talking about before noon or after noon, so people said *a.m.* or *p.m.*, or *in the morning, in the afternoon / evening*. The alternative was to use the 24-hour clock, though only military types ever said 'See you at eighteen hundred hours'. Then technology took some great leaps forward and trains and planes started announcing departure times such as 15.17 and 08.42 (though of course they never did depart on time). Meanwhile, smart phones and smart watches displayed the 24-hour clock as the default, and people looked at their phone and answered '16:45' if you asked them the time at quarter to five in the afternoon.

In 2018, the BBC carried a report that youngsters found it much easier to read digital clock faces than analogue ones (https://www.bbc.co.uk/news/education-43882847), so the shift to the 24-hour clock style of saying the time is most certainly going to become more common. For a long time, the flagship BBC Radio 4's *Today* held out in always saying 'eighteen minutes to seven' instead of 'six forty-two', but in April 2021, one of its presenters said, 'The time is six forty-two, 18 minutes to seven,' in one breath. A tradition in transition? It certainly is a good example of how language doesn't stand still. Perhaps trains and planes will, in the supersonic, robot-driven future, depart at 17-45-point-five. Perish the thought.

TOO or TO

I'm constantly surprised by how often people confuse these in emails; it may be something to do with spell-checkers or it may be a genuine confusion. Remember that the one that means 'also' is too. To is a preposition and is also used as a reduced reference to a previously mentioned verb.

Jim said you're going to the folk festival. We're going too.

I think he should go to university but he doesn't want to.

The one that means an excess of something or more of it than you want is *too*.

It's just too hot to do any gardening today. (not to)

Interestingly, before Shakespeare's time, *too* meaning an excess of something was often written as *to*. Just to complicate matters.

TURNED (A)ROUND AND ...

This is an example of where grammar meets rhetoric and style in speaking, though it's not one that you find much in writing.

I said, 'I've got some good news for you,' and she just turned round and said, 'Well I've got some bad news for you!'

On most occasions, this doesn't mean that someone literally swivelled around physically. It's most often used to emphasize or dramatize a response by someone. Keep it for informal situations.

See also GO IN SPEECH REPORTS

Uυ

UNCOUNTABLE NOUN

See BASIC TERMINOLOGY: A GUIDE

UPPER CASE

See CAPITAL LETTERS

USED TO

There is sometimes a debate about how to spell this verb in the negative and in questions. The negative *didn't used to* is considerably more frequent than *didn't use to*, but both are found. There is another version of the negative, *used not to / usedn't to*, but it is also less frequent than *didn't used to*.

We didn't *used to* grow any vegetables in our garden, but we grow a lot now.

In questions, the form with -d is far more common than the form without.

When you were a kid, did you used to invent imaginary friends?

VAGUE EXPRESSIONS (THINGS LIKE THAT, OR WHATEVER)

Vague expressions such as (and) things like that, and things, and bits and pieces, and that, or whatever, and stuff, and so on and so forth, etc. (etc. is one too) are often thought of as sloppy or lazy uses of English. However, they are extremely common and essential to efficient communication:

I've got to go and buy cutlery and pots and pans and light bulbs and bits and pieces for my new apartment.

They all got drunk and were fooling around and shouting and stuff.

The vague expressions project a shared world; they simply mean 'you know what I'm including here'. Imagine a world where the speaker has to tell you every item they're going to buy for their new home. By the time they mention the bath mat, the fifth lampshade, the egg-timer, the picture-hooks, the bottle-opener, the tea-cosy, the scatter-cushions, the bread bin and the set of six coat hangers, you will have lost the will to live.

There are formality issues, with *etc.* being far more formal than *and stuff*, but, as always, as long as the expression is appropriate to the situation and level of formality, there is no problem.

VARIETIES OF ENGLISH

English has truly become a world language, such that linguists often talk of *World Englishes* in the plural. Independent varieties of English have evolved in many parts of the world where British English was the language of education and officialdom in the colonial era. Varieties such as Indian English, Irish English, Nigerian English, etc. often have their own grammatical characteristics. For example, South and East Asian varieties (Singaporean, Indian, Malaysian, etc.) often make plural nouns which would be uncountable (mass) nouns in my British variety, so we may see forms such as *staffs* (meaning employees), *feedbacks*, *accommodations* and *jewelleries*. We also find minor differences such as the following:

The report emphasizes on the need to tackle deforestation. (Malaysian English)

The report emphasizes the need to tackle deforestation. (American and British English)

The group met to discuss the problem. (British and American English)

The group met to discuss about the problem. (Indian English)

The whole issue has become blurred and complicated. (British and American English)

The whole issue has become blur and complicated. (Malaysian English)

None of these forms, whether Indian, British, American or any other variety, is inherently 'wrong', nor are they 'corruptions' of anything – they are simply variants that have emerged over time. It is up to you to decide what variety you identify with and how that might be influenced by individual situations and different contexts.

VERB

See BASIC TERMINOLOGY: A GUIDE

WHILE and WHILST

These two mean the same, but in British English while is ten times more common overall in speaking and in writing combined. Whilst is ten times more common in writing than in speaking. In simple terms, while wins out, especially in everyday talk. In American English, while is used exclusively in both reading and writing.

Both forms have a long history, and there was even a third form, *whiles*, now obsolete, which occurs around 70 times in Shakespeare's plays.

In the UK, many Yorkshire dialect speakers use *while* instead of standard English *till / until*. A taxi driver in Leeds told me he was working *while Thursday*, then he was going away on holiday.

WHO, WHOM, WHOSE, WHICH, THAT and WHAT

Who, which, that and what

Who refers to people; which refers to things; that can refer to both.

- (1) Who made this mess here?
- (2) Musicians who / that make it to the top of their profession practise for hours every day.

- (3) Which tablecloth do you want, the white one or the red one?
- (4) Something which / that always irritates me is when the weather forecaster tells you how the weather has been rather than how it's going to be.
- (5) A remark (which / that) he made the other day upset me.

Which and that can be omitted in (5).

What is for situations where there's a more open set of choices.

What fish would you like for dinner tomorrow? (choose from a wide range of fish)

Compare this last example with *which* in (3), where the choice is restricted.

However, *what* is often used instead of *which* even when choice is restricted:

What colour wine do you fancy, red or white?

What is considered incorrect in (2), (4) and (5) above, though it is acceptable in some dialects.

Whose

Whose refers to possession. Don't confuse it with who's, which means 'who is'.

Whose jacket is this?

It is a city whose long history is manifested in its rich cultural heritage.

This last example could be expressed more formally as:

It is a city the long history of which is manifested in its rich cultural heritage.

Whom

Whom is the object form of who, i.e. it is used as the object of a verb or of a preposition. It is rather formal.

She is a person whom I regard as one of my great role-models in life. (I as subject regard her as object)

She is a person who / that I regard as one of my great role-models in life. (less formal)

She is a person I regard as one of my great role-models in life. (no relative pronoun – less formal)

She lived with a well-to-do aunt, *from whom* she received a regular income. (formal)

To whom was the letter addressed? (formal)

Who was the letter addressed to? (less formal)

The versions with *whom* are more common in formal writing and can sound out of place or old-fashioned in everyday conversation.

See also APOSTROPHE: WHO'S AND WHOSE, PREPOSITIONS: ENDING SENTENCES WITH

The manager, whom no-one had met in person, was always very ferocious over the telephone.

WORD ORDER

Basic word order in statements

Because English does not have complex word endings that show whether something is a subject or direct or indirect object, for example, which some languages have, word order is quite an important feature of meaning. It can tell us who does what to whom; it can also tell us what parts of the message are to be read as more important than others.

Basic English word order for statements puts the subject first, then the verb, then any objects or complements of the verb. In between, at various points, we find adverbials. Word order alone can tell us how to interpret the basics: we know that *Charlie cooked the fish* is a banal statement about Charlie preparing food. *The fish cooked Charlie* would be front-page news indeed!

Turning things round: the passive voice and agency

The passive voice enables the object (i.e. the receiver of an action) to become the grammatical subject (S = subject, V = verb, O = object):

s v o

Active voice: My grandfather / built / this house.

S V Agent

Passive voice: This house / was built / by my grandfather.

By my grandfather is often called the by-agent: the grandfather is still the 'doer' but is no longer the grammatical subject.

Sometimes it may be pointless to state the by-agent:

Twenty-five people were arrested at the demonstration. (understood: by the police)

But this can also be a way of deliberately avoiding mention of the agent:

The Prime Minister is reported to be considering a controversial new set of planning laws.

Who 'reported' this? The Prime Minister? Some government insider who had a cosy lunch with a journalist?

Information focus

Word order can be manipulated to focus on selected information in the clause. For example, adverbials can be brought to the front of the clause, the infamous fronted adverbials that have plagued the lives of many a primary school teacher delivering the UK National Curriculum to nine- and ten-year-olds, as well as of parents desperately doing their best at home schooling during the coronavirus pandemic of 2020, a generation who often plead that they were never taught such things at school. In the table, adverbials are in bold:

She	has been	a true friend	throughout.
She	has	throughout	been a true friend.
She	has been	throughout	a true friend
Throughout,	she	has been	a true friend.

All of these are ways in which the adverbial can be focused on to a lesser or greater extent.

Turning things round: inversion

Conjunctions and adverbials with negative meanings, when used at the start of a clause for emphasis, are followed by inversion of the subject and verb, just as happens in questions. These words include the conjunctions *neither* and *nor*, and adverbs such as *never*, *seldom*, *rarely*, *scarcely*, *hardly*.

She's not a relative of mine, nor *is she* a friend. We work together, that's all.

We neither want to be there nor do we intend to be there.

Never *did I think* I would get such a lovely surprise party. Thank you, everybody!

In more formal styles, especially literary writing, inversion happens after adverbs like *then*, *later* and *only then*:

He spent three years in New York at the company's headquarters. Then came a year in Kuala Lumpur, building a new base for the company there.

I read the email for a second time. Only then *did I realize* what a mistake I had made.

This book you must buy: object first

This book you must buy has the object before the subject, with a word order O-S-V: object – subject – verb, which is not the typical word order for a statement in English. But it enables great emphasis to be put onto the object this book, perhaps for contrast with other books or just to focus on the book's importance. The neutral version (you must buy this book) gives far less emphasis to the object. More examples:

That question no-one can answer.

The tomatoes we grow ourselves but the mushrooms we buy at our local shop.

Cleft sentences

Compare these examples:

George answered the phone this time, not Harry.

It was George who answered the phone this time, not Harry.

You ought to read her first novel. It's much better than her latest one.

It's her first novel you ought to read. It's much better than her latest one.

I realized on Friday that it was missing.

It was on Friday that I realized it was missing.

The sentences starting with *it* are called *it*-clefts. They are called clefts because they 'cleave' (split) the sentence into two clauses instead of one. They are used to single out one element of a clause, e.g. subject, object or adverbial, for extra focus. This may happen for contrast (in the first example, *George* is contrasted with *Harry*) or to emphasize something important, for example the time something happened (*It was on Friday that I realized it was missing*).

Another type of cleft uses *what*; these are *wh*-clefts. Again they 'cleave' the sentence into two clauses, one of which begins with *what*. Compare the alternative versions:

Next you need to click 'copy', then click on 'paste'.

What you need to do next is click 'copy' then click on 'paste'.

I can't stand those reality TV shows.

What I can't stand is those reality TV shows.

Those reality TV shows are what I can't stand.

Clefts are a useful stylistic device for creating different kinds of information focus. They turn a piece of writing or speaking from a flat landscape into a landscape with peaks and valleys; the peaks are the key information or high points of the text.

See ADVERBIALS, HEADERS AND TAILS

YOU'RE and YOUR

Because the pronunciation of *you're* and *your* is very similar in rapid speech, people sometimes confuse them in writing. *You're* means 'you are':

You're a good friend; I can always rely on you.

Your indicates possession:

Is this your phone? It was on the table.

See also CONTRACTIONS

Y'ALL and YOUSE

Modern English suffers from not having words to distinguish 'you' singular from 'you' plural, unlike French with its *tu* and *vous*, and Spanish with *tú* and *vosotros | ustedes*. But some dialects get around that by saying *y'all* or *youse* when addressing more than one person.

Y'all goin' to the beach today?

Are youse ready yet?

Y'all (contraction of you all), pronounced /jo:l/, with a long sound as in yawn, is most common in the southern states of the USA but is sometimes used in other dialects, too.

Youse began life in Ireland, where it is still heard (especially in the north), and emigrated, along with its users, to America and Australia. It's sometimes pronounced /yuz/ (same sound as ou in you) and sometimes as /yəz/ (same sound as a in ago).

Fn In 2017, the *Chicago Tribune* lamented the decline in the use of *youse* and suggested that it should be revived as greatly preferable to the now universal *you guys*. (https://www.chicagotribune.com/opinion/commentary/ct-language-yinz-youse-perspec-ya-ll-you-guys-perspec-0207-jm-20170206-story.html).

Y'all and *youse* are good examples of how dialect words are often more versatile and can fill gaps in the limited repertoire offered by the so-called 'educated standard'.

Z: THE LETTER

In British English we call it *zed*, while American English calls it *zee*. My prediction is we'll all be calling it *zee* before too long.

ZE and HIR

Recently, *ze* and *hir* have been put forward as gender-neutral pronouns with various forms. *Ze* is pronounced 'zee', and *hir* is pronounced like 'here'.

Wilson is a war correspondent. Ze worked in Iraq and Afghanistan and has recounted *hir* experiences in a new book. (does not tell you Wilson's gender)

As with all new forms, they are not fully part of the language until they have been taken up by the majority of speakers. At the time of writing, they are not widely used. However, they do enjoy a status among users of certain sociolects (the shared language of particular social groups).

ZEBRA

The pronunciation of *zebra* is a bit like the pronunciation of the letter Z, above. However, while North American English prefers 'zee-bra', British English allows both 'zee-bra' and 'ze-bra'.

ZEUGMA

A zeugma is a figure of speech where the same verb is used for two ideas which are quite different, often with humorous intent:

He gave her his overcoat and a strange look.

It is also used as a literary device:

Friends, Romans, countrymen, lend me your ears.

RECOMMENDED FURTHER READING

The Fight for English. How Language Pundits Ate, Shot and Left. By David Crystal. 2006. Oxford: Oxford University Press.

I have no hesitation in recommending any book by the eminent linguist and broadcaster David Crystal. His style is clear, his decades of outstanding scholarship shine through his writing and he has a nice sense of humour. This book delves into public controversies and attitudes to grammar in a non-patronizing way.

Dent's Modern Tribes: The Secret Languages of Britain. By Susie Dent. 2016. London: John Murray.

This is a hugely entertaining book that takes us through the lingo, jargon, in-speak and favourite terms of a wide range of social groups including sportspeople, actors, musicians, politicians, journalists and spies. As I do, Susie Dent confesses a liking and a respect for eavesdropping as a source of scholarship.

English Grammar: The Basics. By Michael McCarthy. 2021. Abingdon, Oxon: Routledge.

In this book I've tried to give a structured picture of all the basics of English grammar. It was inspired by friends and acquaintances who said they'd never been taught grammar at school. I also take you through some theories of grammar and look at the public debates over grammar in the UK, the USA and Australia.

Dialect Matters: Respecting Vernacular Language. By Peter Trudgill. 2016. Cambridge: Cambridge University Press.

Peter Trudgill, like David Crystal, puts academic knowledge across in a non-patronizing way in a style that is easy to read. This

book explores the language of ordinary people. It is thoroughly researched and highly informative. It demonstrates that no dialect is superior to or better than any other.

BACKGROUND READING AND RESOURCES

A Comprehensive Grammar of the English Language. By R. Quirk, S. Greenbaum, G. Leech & J. Svartvik. 1985. London: Longman.

As comprehensive a reference source as you can get and thoroughly reliable. Leaves no grammatical stone unturned. I have had recourse to it on countless occasions.

A Dictionary of Modern English Usage. By H. W. Fowler. 1926. Oxford: Oxford University Press.

A classic by a great observer of English usage and a book that is still quoted as an authority today, thanks to its several editions, including an updated one in 2015. The first edition is a fascinating historical document but a challenging read that demands wading through entries containing many words and phrases that are obscure, rare or now defunct.

A Grammar of the English Tongue. By John Brightland. London, 1711.

One of the several English grammars of former centuries that I have found useful in understanding how our notions of grammar have evolved and how, occasionally, the rules laid out in those old grammars come back to haunt us today. The Cambridge University Library has a wonderful collection of old grammars, both originals and in facsimile form, and some are also available for consultation online in various different editions.

American National Corpus

A huge online database of contemporary American English texts. It has been very useful for comparisons between British and American English usage.

An Essay Towards a Practical English Grammar. Describing the Genius and Nature of the English Tongue. By James Greenwood, Sur-Master of St.-Paul's School. 1711.

Another useful historical source for checking what was considered good usage 250 years ago and how much still prevails today. Greenwood was quite prescriptive and prepared to label certain usages as bad grammar or ungenteel and rude.

A Short Introduction to English Grammar: With Critical Notes. By the Right Rev. Robert Lowth D. D., Lord Bishop of Oxford. London, 1762.

This was a greatly influential English grammar which serves as an invaluable resource for anyone interested in how approaches to the description of English have varied over the centuries, as well as providing evidence for the study of the evolution of the grammar.

British National Corpus (http://www.natcorp.ox.ac.uk/)

A 100-million-word demographically representative database of contemporary written and spoken English that has served me well over the years and is searchable online. A new, updated version of the spoken corpus was recently released (the Spoken BNC2014) and, at the time of writing, an updated version of the written corpus is soon to be released (see http://cass.lancs.ac.uk/bnc2014/).

Cambridge Grammar of English: A Comprehensive Guide to Spoken and Written English Grammar and Usage. By R. A. Carter and M. J. McCarthy. 2006. Cambridge: Cambridge University Press.

My late colleague and friend Ronald Carter and I spent seven years writing this and my head is still crammed with it. It has quite naturally informed, largely unconsciously, many of the statements made in this book. It got us into hot water with the purists when it was published and we had to defend our approach in the media. I cite it in this book as a tribute to the memory of Ron Carter, a superb applied linguist, great friend and colleague of more than 30 years.

Collins English Dictionary Online. (https://www.collinsdictionary.com/dictionary/english/) This is an excellent, up-to-date, freely

searchable dictionary from a publisher that was a pioneer in the 1980s in the use of computerized corpora in dictionary production.

The Collins-COBUILD dictionary for English language learners, published in 1987, broke new ground. The dictionary project was led by my great mentor, Professor John Sinclair (1933–2007), from whom I learnt my trade as a corpus analyst.

Elements of Rhetoric. By Richard Whately (1828). The 1861 edition was used for the purposes of this book, published by the Southern Methodist Publishing House, Nashville, Tennessee.

This work is a reminder of the once very close relationship between rhetoric (the art of using language with the goal of persuasion via speaking or writing), grammar and style, an overlap that is often forgotten in modern-day applied linguistics but which survives in the American tradition of college composition classes and in the fields of literary stylistics and journalistic studies.

English Grammar, Adapted to the Different Classes of Learners. By Lindley Murray. 1795. 16th Edition New York, 1809.

This background reading section lists a number of grammars from previous centuries because I firmly believe that we do ourselves no good service by thinking our present-day grammars are all we should consult. Murray's grammar was hugely popular and influential, and seeing what has changed since his day and that of our other grammarian ancestors is an important lesson in how language evolves and a warning that we should hesitate before disparaging recent and current trends.

English Grammar: The Basics. By Michael McCarthy. 2021. Abingdon, Oxon: Routledge.

This is an introduction to English grammar that takes you through the basic things you need to know about words, phrases, clauses and sentences. My aim was to make grammar accessible to non-specialists. The book also explains some of the more important theories of grammar and the social and political discussions that have surrounded grammar in education and in society in general.

English in Speech and Writing. By Rebecca Hughes. 1996. London: Routledge.

A book that shows clearly how the grammar of speech, even in fairly formal situations such as Parliament, differs from the grammar written down. I have found it immensely useful over the years and its wealth of examples comes to mind every time a pompous politician decries the current state of English grammar.

Google Books Ngram Viewer (https://books.google.com/ngrams)

A great resource that lets you track the use of words across the centuries. See how words compete with one another, how they compare in frequency of use, how they come and go, how variants and different spellings evolve, all in a pleasant, easy-to-read visual display.

Hermes, Or, A Philosophical Inquiry Concerning Universal Grammar. By James Harris. London, 1751.

Another of the old grammars that has provided fascinating insights into attitudes to grammar and ways of describing it. This one is jam-packed with quotations from Ancient Greek and Latin.

Innovations and Challenges in Grammar. By Michael McCarthy. 2021. Abingdon, Oxon: Routledge.

When I was writing this book, I was struck by just how ancient some of the debates over grammatical correctness in English are, and how the legacy of classical Greek and Latin still influences a lot of present-day thinking. I have included a lot of corpus-based examples in the book.

Merriam-Webster Online (https://www.merriam-webster.com/)

The Merriam-Webster online dictionary describes itself as 'America's most trusted online dictionary for English word definitions, meanings, and pronunciation'. It certainly is a wonderful source of information on American English and the dictionary has a long history going back 200 years.

Oxford English Dictionary Second Edition on CD-ROM (v. 4.0). Oxford University Press 2009.

Undoubtedly the most important resource for anyone researching the origins, evolution and usage of the vast treasure-house of English words and phrases. This was the version I used when I started researching this book. I now use the online version, which is very easy to search.

Pamphlet for Grammar. By William Bullokar. Imprinted at London: By Edmund Bollifant, 1586.

Held to be the first proper English grammar, this is an interesting if challenging read. Amongst other things, what it shows us is that the eight basic parts of speech that we are familiar with today were already established more than 400 years ago. Everything is described in terms of Latin (cases, declensions, etc.). It is available through the Oxford Text Archive. (http://ota.ox.ac.uk/desc/0025)

The English Grammar. By Ben Jonson. 1640 (originally written in 1623 but published posthumously).

A window into grammatical description and attitudes all those centuries ago and another reminder that some of the issues that are still debated today are as old as the hills. For instance, Jonson championed speech over writing, stating, 'Grammar is the art of true, and well speaking a language: the writing is but an accident'. Jonson's grammar is accessible via the excellent Scolar Press (Menston) edition of 1972 (quoted here, p. 35).

The Royal English Grammar: Containing What Is Necessary to the Knowledge of the English Tongue. By James Greenwood, Sur-Master of St.-Paul's School. London, 1737.

Grammar manuals blossomed in the 18th century and, although often prescriptive and founded on the notion that English should be squeezed into a Latin straitjacket, they contain invaluable insights into contemporary usage and attitudes and offer the potential for fruitful comparisons with grammar of the present day.

Shakespeare's Non-Standard English. By Norman Blake. 2004. Third edition 2006. London: Continuum.

A wonderful dictionary of Shakespeare's use of informal and non-standard language, with detailed references to the original works and useful commentaries on forms and functions. The book reminds us that Shakespeare's grammar and vocabulary were not always high-flown and solemn but drew richly from across the vast spectrum of English. It serves as an invaluable source of information on contemporary usage as well as Shakespeare's creativity with words and structures.

BASIC TERMINOLOGY: A GUIDE

Word classes

The table shows the main word classes that it is useful to know about in order to understand grammar more effectively.

This is not a complete list of grammatical terms, just the key ones that are used in this book. More terms are explained in the individual entries, where relevant.

There are cross-references to it throughout the book if you need them.

NAME	EXPLANATION	EXAMPLES
noun	name of a person, place, idea or thing	book, engineer, Zoe, London, friend, life, music
countable noun	noun that can be made plural	pen(s), tree(s), boy(s), friend(s)
mass or uncountable noun	noun not normally used in the plural	information, rice, furniture, progress, petrol, music
verb	word expressing a state, action, event or process	sing, grow, seem, be, have, will, can, allow, write
auxiliary verb verb that comes before a main verb and indicates something about time or whether something is a question, etc.		be, have, do

(Continued)

NAME	EXPLANATION	EXAMPLES
modal verb	verb that comes before a main verb and expresses degrees of certainty or obligation, as well as expressing politeness	can, may, should, would, shall, must, will
phrasal verb	verb consisting of a verb and a particle	take off, get up, pop in, look out
adjective	word describing a quality possessed by a noun	big, lovely, excited, disturbing, wooden, Peruvian
adverb	word that says something about an action, process or quality	quickly, often, sadly, alright, immediately
preposition	word that shows a relationship (e.g. time, place) between words	in, at, on, of, between, from
determiner	Word that specifies something about a noun (e.g. quantity, possession, definiteness)	the, a(n), my, her, some, these, three
pronoun	word that refers to people and things without using a full noun	me, she, it, ours, I, him, those, we, who, someone, nobody
conjunction	word that links two items (e.g. two words, two phrases, two clauses)	and, but, or, because, before, after, when, if, so

Phrases

A phrase is a word or group of words that form a unit of meaning in a clause. The term can be a bit misleading, since, when we come to look at clauses, we will see that 'phrase' is defined in terms of its role in the clause, so a 'phrase' can consist of just one word or several.

NAME	EXPLANATION	EXAMPLES
noun phrase	a head noun with any words before or after it that belong to it	music, my own car, coffee with milk, three days in a row, the woman who got the job
verb phrase	a main verb and any auxiliary or modal verbs before it	sit, might happen, can't sleep, ought to work, will arrive
adjective phrase	an adjective with any words before or after it that belong to it	easy, very silly, quite cold, good enough
adverb phrase	an adverb with any words before or after it that belong to it	foolishly, very slowly, quite badly, carefully enough
prepositional phrase	group of words beginning with a preposition and completed by a noun phrase	In the morning, at sunset, from Texas, over the bridge, to Adelaide

Words and phrases such as wow, gosh, heavens above are often called interjections.

You may have come across the terms gerund and gerundive. A gerund is the -ing form of a verb acting as a noun (e.g. Smoking is bad for you). A gerundive is a form of a Latin verb that acts as an adjective, expressing things that should or must be done. Latin gerundives are fossilized in English words such as addendum (something that must be added) and referendum (something that must be referred back to the people in a vote).

You can survive perfectly well in English without ever using the terms gerund or gerundive.

Clauses

A clause is a group of phrases focused around a verb phrase. In the following examples, each phrase is separated by /. Clauses are separated by //. Verb phrases are in italics.

We / laughed.

That winter / was / very cold indeed. (one clause)

You / should call / the airline / before departure. (one clause)

Give / me / a call // when / you / get / this message. (two clauses)

Hoping / for a good result, // he / emailed / his application. (two clauses)

Subjects, verbs, objects, complements, adverbials

The phrases which make up clauses play different roles as subject, verb, object, complement or adverbial.

Subjects are the 'doers' or 'agents' of what happens in the verb phrase.

Objects are the 'receivers' of what happens in the verb phrase.

$$S = Subject V = Verb O = object$$

S V C

We / love / Japanese food.

s v o

They / welcomed / their guests.

Some verbs can have two 'recipients' of an action, termed *direct* (DO) and *indirect* (IO) objects. The indirect object (the person or

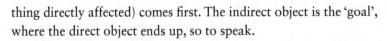

IO DO

She gave <u>him a book</u>.

IO DO

I've knitted you a scarf.

With verbs like be, seem and become, nobody 'does' anything to anybody or anything, so we don't call what follows the verb an object; instead we call it a complement (C):

S V C

His brother / is / an actor.

S V C

It / seemed / illogical.

Clauses often also contain information about the circumstances surrounding an event, for example when, where, how or to what extent it happens. This information is contained in adverbials (A):

S V O

We / get / a takeaway / every Friday evening.

S V C A

There / is / more seating / upstairs.

Transitive and intransitive verbs

Some verbs don't need an object. When used in this way, they are *intransitive* verbs.

She laughed. (S / V)

I ran to the station. (S / V / A)

Jim arrived yesterday. (S / V / A)

Some verbs need an object (underlined). When used in this way, they are *transitive* verbs.

He got a new bike.

I like horror films.

Some verbs are used with two objects (underlined). We call these ditransitive verbs.

She lent me an interesting book.

They offered the villagers an option to buy the property.

Active and passive voice

Maurice painted this picture is an active voice clause: Maurice is the doer and is the subject of the clause.

This picture was painted by Maurice is a passive voice clause. Maurice is still the doer, but the picture is now the grammatical subject.

Main and subordinate clauses

Some clauses can stand on their own two feet, so to speak. They don't need another clause to make sense or to convey a complete message. They are *main clauses*.

He got a new bike.

I like horror films.

Both of these clauses are complete in themselves.

Some clauses need to be attached to a main clause in some way in order to make sense or to convey a complete message. Consider these examples:

When I arrive ...

If it rains ...

Because it was so cold ...

As I was leaving ...

They leave us hanging in the air. They need more to make sense:

When I arrive, I'll give you a call.

We'll stay home if it rains.

Because it was so cold, we lit the stove.

I picked up some leaflets as I was leaving.

The underlined clauses are subordinate clauses.

Sentences

A sentence must contain at least one main clause. It can contain more than one main clause or a combination of main and subordinate clauses. In writing, sentences start with a capital (upper case) letter and end with a full stop (period). In ordinary, everyday conversation, we don't really speak in 'sentences'. Linguists prefer to talk about 'utterances' and conversational transcripts show that a lot of our speech consists of phrases or short clauses.

Because it is beautiful. (strictly speaking, not a sentence because there is no main clause, though you might see it in literature or advertising texts)

He cooked us a wonderful meal. (sentence: one main clause)

When we arrived, he cooked us a wonderful meal. (sentence: subordinate clause and main clause)

He cooked us a wonderful meal and I loaded the dishwasher. (sentence: two main clauses connected by *and*)

When we arrived and after we'd unpacked, he cooked us a wonderful meal and I loaded the dishwasher. (sentence: two subordinate clauses connected by *and*, and two main clauses connected by *and*)

A-Z TEXT INDEX

AAPA **ABBREVIATIONS** ACCEPT and EXCEPT ACCOMMODATION **ACROSS ADJECTIVE ADVERBIALS** What adverbials do in clauses Fronted adverbials ADVERBS (WELL, SUDDENLY) AFFECT or EFFECT AGREEMENT (CONCORD) Subject-verb concord (I work, she works) Nouns that are always plural (politics, economics) Subjects linked by and (Harun and his brother were there) Complex subjects (the risk of infections, pressures on the living wage) What-clauses as subject (what we need is more money) Agreement with either ... or, neither ... nor, both ... and Agreement with neither of and none of Agreement with words like majority, government, army

AHEAD OF

ALL and ALL OF ALL RIGHT or ALRIGHT ALL TOGETHER or ALTOGETHER ALTERNATE or ALTERNATIVE A LOT and ALOT AMERICAN and BRITISH **ENGLISH** American influence on British English American and British grammar: some current differences American influences: phrasal verbs American influences: social routines American influences: pronunciation AMOUNT OF or NUMBER OF **ANACOLUTHIA** ANOTHER / A WHOLE NOTHER ANY MORE or ANYMORE **APOSTROPHES** What's an apostrophe and what's it for?

Possession, close association

(Jack's coat, Denmark's

economy)

More than one possessor (Nick and Claire's house) Apostrophe: noun phrases (the woman in red's husband)

Apostrophe: street names, signs, etc.

Contractions (I'm Welsh, she's Australian)

Apostrophe: the 1920s, the 1840's

Apostrophe: five minutes' walk

Apostrophe: who's and whose

Apostrophes and plurals
AROUND and ROUND
ARTICLES (INDEFINITE,
DEFINITE)
AS versus LIKE
AS LONG AS and SO LONG
AS

AUXILIARY VERB

BESIDE or BESIDES
BETWEEN or AMONG
BETWEEN YOU AND ME
BORROW, LEND and
LOAN
BOUGHT and BROUGHT
BRITISHISMS

-CE or -SE (PRACTICE, PRACTISE) CAN, MAY and MIGHT CAPITAL LETTERS
CLAUSE
CLEFT SENTENCES
CLICHÉS
COLON
COMMA

Commas in lists (laptops, tablets and phones)

Commas with adjectives (a long, blue, silk dress)

Commas: more than one main clause (she sings and plays the guitar)

Comma-splices

Commas after subordinate clauses (if you're driving, avoid the M25)

Commas before and after embedded clauses (we could, if you prefer, leave earlier)

Commas and linking words and phrases (it could cost a lot more, however)

Commas around noun phrases in apposition (Jim, the eldest son, is in prison)

No comma between subject and verb (the person who did it was drunk)

No comma between be and its complement (the problem is that ...)

Two main clauses

Commas separating off adverbial phrases (I love cakes, especially at teatime) Commas and vocatives: people directly addressed (Julia, come here, please) COMPARE TO and COMPARE WITH COMPARATIVES (BIGGER, EASIER) Comparative adjectives and adverbs (bigger, worse, more slowly.) Comparisons with as ... as, not as ... as, not so ... as COMPRISE and CONSIST CONJUNCTIONS CONTINUOUS and CONTINUAL CONTRACTIONS CONTRIBUTE, DISTRIBUTE (STRESS) CORPUS / CORPORA **COUNTABLE NOUN COUNTRIES** CREATIVE WORD-**FORMATION** Creative suffixes (Irangate, workaholic) Back formations (liaise, babysit)

Conversion (a big ask)

Blends (smog, brunch)

footy)

Clipping (barbie, maths,

CRITERION / CRITERIA, PHENOMENON / PHENOMENA

DASHES DATA DEFINITE(LY) DETERMINER DIFFERENT TO, FROM, THAN DIALECTS and STANDARD **ENGLISH** DOUBLE IS (THE THING IS IS ...) DOUBLE NEGATIVES Double negatives: when best not to use them (she hasn't got no money) Double negatives for emphasis with adjectives (not unreasonable) Other kinds of double negative (she's not here, I don't think) DUE TO and OWING TO DUNNO, GONNA, GOTTA, WANNA

EACH OTHER and ONE ANOTHER EITHER and NEITHER ELDER and ELDEST ELLIPSIS (POSTMAN BEEN YET?) ENDINGS IN -WARD or -WARDS (TOWARD[S])

ESPECIALLY and SPECIALLY EVERY DAY and EVERYDAY EXCLAMATION MARK (!)

FARTHER / -EST or FURTHER / -EST FIRST(LY), SECOND(LY) FULL STOP or PERIOD FRONTED ADVERBIALS

GAOL and JAIL GERUND GET

What you may have heard at school
Past participle (got or gotten)
The passive with get (she got fired)

Go in speech reports (he goes, where are you?')

Grammar GUYS

H- IN WORDS LIKE
HISTORIC AND HOTEL
HAD BETTER
HARDLY and HARD
HAS YET TO and IS YET TO
HEADERS and TAILS (MY
SON, JAMES, HE'S A
PILOT)
HE / SHE, HE OR SHE,
THEY (EVERY CITIZEN
SHOULD DO THEIR

HOWEVER HYPHENS

> Hyphens: current usage Hyphens: compound adjectives before nouns (a well-known composer)

> Hyphens: compound nouns (lamp-post or lamp post)

Where hyphens are still used (sister-in-law, self-catering)

When not to use hyphens (we need to set up the room)

IF: STANDARD and NON-STANDARD USES

Standard form (if I won the lottery ...)

Extra verbs added (if it hadn't have been for him, ...)

INDIAN ENGLISH
If I was / if I were
INTERJECTIONS
IRISH ENGLISH
IT'S or ITS

JARGON

KIND, SORT and TYPE

LEND
LESS and FEWER
LET'S
LIE or LAY
Lie, lay, lain
Lay, laid, laid

DUTY)

LIKE (IT WAS CRAZY, LIKE!)
LIKELY
LITERALLY
LOAN
LOAN WORDS (KEBAB,
MACHO)
LOOSE and LOSE
LOTS OF

MADE OF, FROM, WITH,
OUT OF
MALAPROPISMS
(ACRIMONIAL DEBATES)
MALAYSIAN ENGLISH
MASS NOUN
MAY BE and MAYBE
MEDIA
METER and METRE
MISPLACED PARTICIPLES (A
HARE DRIVING HOME)
MISS (VERB)
MISS, MS, MRS, MR,
MASTER
MODAL VERB

NEVERTHELESS and NONETHELESS NOUN

OFF
OLDER, ELDER, OLDEST and
ELDEST
ONES and ONE'S
ONE IN THREE, ONE IN
FOUR, ETC.
OUGHT TO

PAST and PASSED PAST TENSE (TOOK) and PAST PARTICIPLE (TAKEN) Forms and examples Past tense and past participle ending in -t or -ed (learnt or learned) PERIOD (.) PHRASAL VERB PHRASE PREFIXES (UN-, IN-, DIS-) Prefixes: use and examples Prefixes: variant forms (unfeasible, infeasible) Prefixes and hyphens (pre-1980, prewar) Prefixed adjectives: no non-prefixed equivalents (disgruntled) PREPOSITIONS (TO, FROM, OF) Prepositions and object pronouns (to me, from us) Prepositions: ending sentences

PRONOUNS (I, ME, WE, US, THEY, THEM) Subject and object pronouns (I, we, me, us) Object pronouns (let Margaret and me know)

with

PRINCIPAL and PRINCIPLE

Object pronouns (it was me / him / etc. that did it)
Pronouns: object and possessive forms before -ing (do you mind me / my asking?)

PRONOUNS ENDING
IN -ONE AND -BODY
(ANYONE, SOMEBODY)
PROVIDED and PROVIDING
(THAT)
PUNCTUATION

QUESTION MARK

Direct questions (is she your teacher?)

Statements heard as questions (you're not coming with us then?)

Indirect questions: no question mark (I asked her if she was okay.)

Question marks in polite requests (would you pass me that book?)

Rhetorical questions
QUOTATION MARKS /
INVERTED COMMAS
('...')

RAISE, RISE and ARISE
Rise
Raise
Arise

REFLEXIVE PRONOUNS (MYSELF, YOURSELF) REGARD (REGARDING, WITH / IN REGARD TO. AS REGARDS) RELATIVE CLAUSES (THE GIRL WHO BROKE THE WINDOW) Defining relative clauses (a van that was left unattended) Non-defining relative clauses (Waterford, which is Ireland's oldest city, ...) Sentential relative clauses or comment clauses (.... which is pretty cheap really) RIGHT(LY), WRONG(LY)

SEMICOLON
SENTENCE
SHALL and WILL
SIGHT or SITE
SINGAPORE ENGLISH
SO
SOME TIME or SOMETIME
SOMEWHAT
SPEAKING and WRITING
SPELLING: OR and OUR
SPLIT INFINITIVES
STATION
SUBJUNCTIVE (I INSIST
THAT HE APOLOGIZE)

SUFFIXES (-FUL, -ITY)
Suffixes: use and examples
Suffixes: -ic or -ical
Suffixes: gendered / sexist
terms (headmistress / waiter)
Suffixes: variants
(individuality,
individualism)
Suffixes: bits of 'tat'
(preventive, preventative)
Suffixes: overloading
(hallucinatorily)
Changing suffixes (racialism / racism)
SUPERLATIVE (BEST, MOST

TAUTOLOGY (A ROUND SPHERE) THAT OF THE and TO: PRONUNCIATION THERE IS and THERE ARE THERE, THERE'S, THEIR. THEIRS, THEY'RE THEY / THEM / THEIR / THEIRS: SINGULAR and GENDER-NEUTRAL THOSE and THEM TILL and UNTIL TIME, and HOW WE TELL IT TOO or TO TURNED (A)ROUND AND ...

FRIGHTENING)

UNCOUNTABLE NOUN UPPER CASE USED TO

VAGUE EXPRESSIONS (THINGS LIKE THAT, OR WHATEVER) VARIETIES OF ENGLISH VERB

WHILE and WHILST WHO, WHOM, WHOSE, WHICH, THAT and WHAT Who, which, that and what Whose Whom WORD ORDER Basic word order in statements Turning things round: the passive voice and agency Information focus Turning things round: inversion This book you must buy: object first Cleft sentences

YOU'RE and YOUR Y'ALL and YOUSE

Z: THE LETTER ZE and HIR

ZEBRA ZEUGMA

ACKNOWLEDGEMENTS

Many thanks to the following, without whom this book would never have seen the light of day: academic colleagues at the universities of Birmingham, Nottingham, Limerick, Cornell, Penn State, Valencia, Newcastle and Cambridge for years of shared ideas and insights; my late friend, the grammarian Amorey Gethin, first and most important mentor of my teaching career; Mr Brian Mark, my secondary school English teacher; his daughter, applied linguist and grammarian Geraldine Mark, for her review of the manuscript; Professor Michael Handford, renowned corpus linguist, for his review of the manuscript; the late Professor Ronald Carter, friend, colleague, co-author and professional partner for more than 30 years; the late Dr David Brazil, mentor, colleague, friend, a most original thinker in the fields of grammar and phonetics; Dr Anne O'Keeffe, co-author and corpus researcher in grammar and pragmatics; Dr Felicity O'Dell for years of coauthoring books on English vocabulary; Professor Paula Buttery for assistance with computational ideas for analysing language; Michael Swan, professional friend and extraordinarily perceptive grammarian; the late Professor John Sinclair, pioneer of corpus linguistics, who taught me everything about using and interpreting language corpora; Sarah Cole, my publisher, for her unstinting faith in the project and for her support throughout; and finally, thanks to my wife, co-author and co-researcher, Jeanne McCarten, for the best and happiest days of my life.

ABOUT THE AUTHOR

Michael McCarthy was born and grew up in Splott, Cardiff, UK. He studied Modern and Medieval Languages at Downing College, Cambridge from 1966 to 1973, where he received his MA and PhD. He later trained to be an English teacher at the University of Leeds.

He is Emeritus Professor of Applied Linguistics in the School of English, University of Nottingham, UK. He has also served as Visiting Professor in Applied Linguistics at the University of Limerick, Ireland, and Newcastle University, UK, and as Adjunct Professor at Cornell University and Penn State University, USA. He holds an Honorary Professorship at the University of Valencia, Spain. For the last 39 years, he has worked with corpora of spoken and written English, investigating them to establish how the vocabulary and grammar of English are used at the present time and how they are evolving and changing.

He is author / co-author of more than 50 books and over 100 academic papers dealing with the description and teaching of the English language, especially as a second or foreign language and with a focus on the spoken language. He has lived and taught in Britain, the USA, The Netherlands, Spain, Sweden and Malaysia. He is co-author of the 900-page English Grammar Today and the globally successful Touchstone and Viewpoint courses for adult learners of English (all published by Cambridge University Press). He has lectured in 46 countries on aspects of English and English teaching and has spoken about grammar in radio and TV interviews in different parts of the world. He is a Fellow of the Royal Society of Arts.

@ProfMMcCarthy

(© Jeanne McCarten 2021. By kind permission)